The
VICTORIAN
Traveller's Guide to
OXFORD

The VICTORIAN Traveller's Guide TO OXFORD

EDWIN ENGLISH

AMBERLEY

Front cover image courtesy of the Library of Congress.

First published in 1901
This edition published 2014

Amberley Publishing
The Hill, Stroud
Gloucestershire, GL5 4EP

www.amberley-books.com

British Library Cataloguing in Publication Data.
A catalogue record for this book is available from the British Library.

ISBN 978 1 4456 4306 9 (print)
ISBN 978 1 4456 4322 9 (ebook)

Typesetting and Origination by Amberley Publishing.
Printed in the UK.

Contents

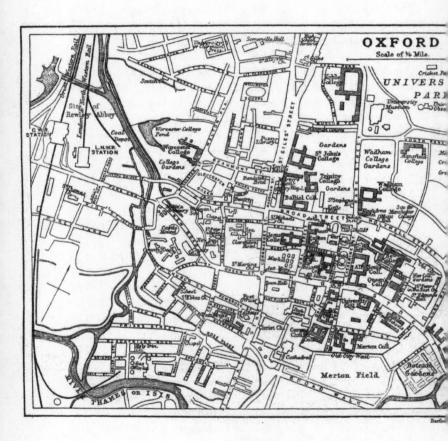

INTRODUCTION

The name of Oxford is accepted as proof of its very great antiquity; it being the Celtic form of Ousen-ford, the ford across the water, as in Ousen-ey, or Oseney, intimating the existence of an island. The later name of Oxna-ford (though an early one), like the Ox-ford of today, is a departure from its original intention, though not by any means inappropriate, and is in agreement with the Arms of the City, in which appears the ox crossing the ford. For two centuries, between 626 and 827, Oxfordshire had been a frontier country between the West Saxons and the Mercians, and Oxford, itself a ville on the border of the Thames, the natural boundary-line between the two great kingdoms, had been the constant scene of struggle, and had belonged alternately to Mercia and Wessex. In the year 827 Egbert of Wessex, having brought Mercia under his sway, consolidated his power, and Oxford being no longer a frontier town had peace and made rapid progress.

During these two centuries great and import events had been in progress at Dorchester, within eight miles of Oxford; events which must have exercised great influence amongst the inhabitants of this district. It is at this early date that the religious life of diocese of Oxford begins. Quoting from Bee *Ecclesiastical History*, we find 'that in the reign King Cynegils, in the year 634, the West Saxons were visited by Birinus, who expressed in the presence Pope Honorius his intention to 'scatter the seeds of faith' in the remote districts where no preacher of truth had been before. When he came into Britain first visited the West Saxons, and found them utter pagans. Having determined to attempt conversion he was soon after rewarded by the conversion of the King, and subsequently his people. At baptism of Cynegils, Oswald, the King of the Northumbrians, acted as his godfather, and together they made a gift to Birinus of the City of Dorcis, that it might become the seat of a bishopric. Other royal baptis followed in those of King Cuthred and King Cwiche the son of Cynegils.' Birinus died in 650, and buried at Dorchester. The influence and extent of this diocese continued to increase so rapidly under the successors of Birinus that in 673, on September 24th, we find a Council was held by Archbishop Theodore at Hertford, at which 'all

the Anglo-Saxon bishops were present, except Bishop Wini,' who had been expelled from the bishopric of Dorchester for simony; and in 703, upon the death of Bishop Heddi, it was finally determined, 'by a Council of the Fathers of the Church and the Kings,' that the 'great' diocese of Wessex was too large to be governed by a simple bishop, and Oxfordshire was accordingly assigned to the See of Winchester. The influence of these stirring events must have been greatly felt at Oxford, and probably had a direct influence upon the establishment of the 'religious house,' founded by St Frideswide, who died in 740. Although both monasteries and nunneries existed in England earlier than this date there is reason to believe none existed in this district until the foundation of St Frideswide's Nunnery, about 727; as an old document, which shows how the church (now the cathedral) was re-built in 1004, gives the following narrative of the original foundation of the religious house. One Didarus, 'King of Oxford,' gives the site to his daughter, St Frideswide, the most holy virgin, and raises there a nunnery for her. William of Malmesbury supplements this account by a story of Frideswide being sought in marriage by a king, named Algar, whose suit she rejected, dedicating her'virginity to Christ. Finding her lover importunate she flies into the wilds of Oxford, and when he still follows her strikes him with blindness, but on his repentance gives him his sight again. Falkner, in his *History Oxfordshire,* says, 'There is nothing improbable either in there being one Dida, a sub-king of 1 Oxfordshire district at this time, or in his buildi there a nunnery for his daughter, and St Frideswid Nunnery may be thus considered to date from early the Eighth Century.'

This house was replaced by a foundation for secular canons, and in 1004 some 'inns' were provided the King for those who sought the benefit of th learning and piety. In these 'inns,' afterwards 'halls,' we may reasonably suppose we get the earliest glimpse of the future student life of Oxford, although it did not aspire to the collegiate life until some centuries later, when in 1264 Walter de Merton transferred his scholars from Malden in Surrey, and made his headquarters at Oxford, thus

establishing Merton College; his students being the first to live together in one building for the purpose of removing them from the evil influences of the crowded town. Falkner in later researches makes the transfer of students to in 1294.

THE SAXON MOUND
One of the most striking features of ancient Oxford and one also that cannot fail to attract the attention of any person in visiting the City today, is that extraordinary Mound which is passed in the New Road, upon approaching the City from the railway stations. The Castle, under whose shadow so to speak the Mound lies, is said to have been the first stone building of any importance that Oxford had seen, but this Mound, green and fresh as ever today, must have been in existence nearly two centuries before the erection of this Castle, in the reign of William the Conqueror. It is reputed to have been raised by Hithelflaida, Lady of the Mercians, who had 'built a castle' at Oxford about 910, and although Saxon stonework is known to have been erected occasionally during the previous century, history seems to substantiate the conclusion that this Mound was the 'Castle' referred to as built by the Lady of the Mercians. As strongly supporting this view we find the following passages in *Cassell's History of England,* 'In 910, the war between the two races (Saxons and Danes) broke out once more, and lasted with brief intermission, for ten years; when the Danes, finding they were losing ground, sued for peace. Those who inhabited Mercia were the first to submit. Edward, the King (who was the son of Alfred the Great) was materially assisted in these struggles by his warlike sister, Elfieda, the widow of the Earl of Mercia, who despite her sex, appears to have delighted in war. Aided by her brother's troops, she attacked the Welsh, who had sided with the Danes, and obliged them to pay tribute to her.' We may therefore justly conclude that this warlike princess, immediately upon the renewal of the war, hurriedly raised this Mound for defensive purposes, which with its artificial defences, probably consisting of earthworks and ditches surrounding it, excepting on the north-west side

which was protected by river must have been at that date a very strong defense fort. Nearly at the summit of the Mound is the entrance to a well-room, made in the reign of Hen II., during the latter half of the twelfth century. This also is in good state of preservation at the present day it is said to have a depth of 82 feet, the sides being stones well fitted together, and although without wat now, within living memory water was had from the well; the disappearance being caused by the sanita drainage system of the City about 40 years since.

There is every reason to conjecture that for many years previous to the date of the erection of this Mound the Saxon Kings had a Royal Residence here, with the precincts of the present gaol. Some early portion of the Saxon Chronicle were undoubtedly written during the reign of Alfred the Great, as it becomes very full detail in regard to his wars with the Danes, which would give the date as the close of the Ninth Century-Alfred's death being in 901. The first historic mention of Oxford is from this Chronicle in the ye 912, 'King Edward took possession of London and Oxford,' after which there are several references the births and deaths of Saxon Kings and Princes taking place here, and also to several 'gemots' Councils of the nation being held at Oxford up to 106 the year before the Norman Conquest. Dr Ingrai states that Oxford was for some time the Metropo of the Mercian district, and favourite seat of the Saxon monarchs, as it was afterwards of the Danes.

THE NORMAN CASTLE

The Castle adjoining, the building of which was commenced in 1071, is undoubtedly one of the oldest of the Norman buildings in England, as its building commenced within five years of the Normans landing in Sussex, and during those eight centuries this uncouth block of masonry has stood unchanged frowning upon the City. Having now reached the age at which records were kept by the monkish historians we emerge from legend and myth, and find our authorities in historical records, or so-called 'chronicles.' It is extremely interesting to note how the

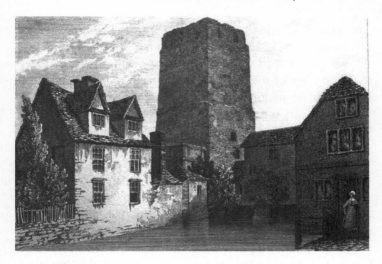

Oxford Castle in 1832.

monkish historians mix up legends with facts, exhibiting their superstitious fears. At this date Robert D'Oyly was appointed 'Constabularius' of Oxford by William the Conqueror. His first precaution in these troublous times, with the Norman hold on the country so insecure, was to establish himself firmly on a defensive base; and he therefore immediately set to work to strengthen the already existing Mercian's fortress by a series of castles – six of which he is said to have built – to complete his fortress; the Castle now standing being one of the Bastion Towers commanding the western approach to the town. The Chronicle of the Abingdon Monastery and also of Osney Abbey give a good deal of attention to D'Oyly, who is the principal figure in the history of Oxfordshire at this date. He is said to have raised money for building principally from the Church, which surmise seems to be justified by the abuse of the monkish historians. An interesting instance of this is worth copying from the Chronicles of Abingdon, 'In his (Robert D'Oyly's) lust of money he harried the churches everywhere, but especially the Abbey of Abingdon; to wit, he took away their possesions, and sued them constantly at law,

and sometimes put them at the mercy of the King. Amongst other evil deeds, he took away a certain mead that lay outside the walls of Oxford with the King's consent and made it over to the soldiers of the Castle for the use. This loss grieved the brethren of Abingdon more than any other evil.' But soon after, when his position had become secure, he became a benefactor instead a persecutor, and built churches, and thus secured their good will. The Chronicle continues: 'This happy change was in answer to the monk's prayers, who prayed for an illness to correct him; and to an evil dream in which he saw himself arranged before the Blessed Virgin and tormented with imps. As before that dream he was a plunderer of churches and of the poor, so after it he was made a repairer of church and a helper of the poor, and a doer of many good works.' The Castle commanding the waterway was of special importance in those early days in consequent of the badness of the roads, waterway being used wherever possible. After D'Oyly's evil dream he went by water to Abingdon to make reparation, and the monks afterwards made a profit by blocking the main stream, and exacting a toll of 100 herrings from each boat, using another channel which passed the Abbey and which they kept open.

The defensive powers of this Castle were striking shewn in the following century when, in 1141, Maud being driven from London, took refuge in Oxford Castle, which was given up to her by the younger Robert D'Oyly, nephew of the builder. King Stephen pursued to Oxford, and besieged the Castle, which was successfully defended for ten weeks, after which, the food giving out, surrender took place; Maud having escaped the night before the surrender. A vivid description of the escape is given by Falkner in his *History of Oxfordshire*, from which the following extract is taken: 'There was a severe frost, the river and flooded meadows were hard frozen, and deep snow had fallen afterwards and covered everything. In the dead of night, Maud, with one or two attendant knights, slipped out of a postern, and being all of them clothed in white, they escaped the notice of the outposts as they crossed

the snow. The surroundings seem strangely familiar, and it requires no great effort of imagination to picture the wintry scene, the level mantle of sparkling snow, the frozen river and ditches, and perhaps a searching wind sweeping over the levels of the Thames Valley as pitilessly as it does today. The little party made their way on foot across the marshes to Bagley Hill, and climbing it came down on Abingdon, where they found horses to carry them to Wallingford.' At a recent visit to the Castle the writer found that the top is now reached by ioo stone steps (stone, with wooden casings to each); at the top are six doorways, where the besieged could build out wooden protected battlements for defensive purposes, such as pouring boiling pitch or oil on to the assailants. At the basement the walls are 9 feet 3 inches in thickness. The other five towers were demolished about 1648.

DOMESDAY SURVEY

At the time of this Survey, in 1085, which was made for purposes of taxation, Oxford was in grievous state of disrepair and dilapidation. Before the Conquest, in the reign of Edward the Confessor, there were recorded 721 houses in Oxford but at Domesday only 243 of these remained inhabited: 478 being returned as *vastae, i.e.,* unoccupied destroyed. Its extent probably corresponded with the line of walls afterwards built in the reign of Henry III; the western wall reaching to the Castle and river on the east to the end of New College Gardens, on the south running along the back of Merton College Gardens, crossing St Aldates, just below Christ Church Gateway, with the south portion of Pembroke College built upon the wall; and the north wall crossing Corn Market Street at St Michael's Church between the houses of Ship Street and Broad Street, across the Quadrangle of the Old Schools until it joined with the Tower of New College. The City was divided then as it is today by the two great crossroads, the point of crossing being known as Quatrevoies or Carfax of the present date.

The last entry of Oxford in Domesday is very interesting, being that 'all burgers of Oxford have common pasture outside

the walls, returning s shillings and eight pence.' This common pasture the present Port Meadow of 439 acres. Falkner says 'It is very remarkable that this great tract of common land should have escaped the hands of land-grabbers for 800 years, and be still serving the same purpose to-day as it did in the time of the Conqueror; even Robert D'Oyly, who was so prone to annex meadows, laid no hand upon it.'

The King's dues from Oxford at this time are also shown to have increased to £60; having been in the time of Edward £20 and nine pints of honey. He also had a claim on the City for twenty burghers when wanted, or a further payment of £20 from the City as an exemption of all citizens from service.

THE ANCIENT CHURCHES OF THE CITY

At Quatrevoies it is generally acknowledged the first parish church was built. The Chronicles of Abingdon Abbey has record of its building in the year 1034, and makes Cnut its founder. Domesday does not enumerate all the churches in Oxford, but mentions several others, St Mary the Virgin, St Michael, St Ebbe, St Peter, and St Frideswide. Some of these churches were in a very bad state at this date, as the Chronicle goes on to say that Robert D'Oyly on his recovery from a dangerous sickness 'evinced his penitence by rebuilding at his own costs the parochial churches which were in ruins both within and on the outside of the walls of Oxford.' The St Michael's Church referred to stood at the north gate, but a second St Michael's was standing at the south gate, which was pulled down upon the building of Christ Church in the Sixteenth Century; a second St Peter's (known as 'le Bailey'), stood near the we gate, which has been removed within living memory. St Mary Magdalen Church is also said to have been built by D'Oyly, but it was outside the walls of the City; the same remark also applies to the Church Holywell, the chancel arch of which is very early, and the Manor of Holywell being held by him it may very possibly be attributed to his foundation, although some authorities differ in this. It is important note that St Aldate's Church is said to have

been restored in the year 1004, the author) being Ingram, in his 'Memorials of Oxford'. The reason why it was not mentioned in Domesday probably being that it was then attached to St Frideswide. Some of the stone seats or arched sta were discovered early in the nineteenth century, having been hidden away behind the panel-work. Coming little later we find the lower part of the tower of St Giles' Church, also outside the north gate of the City dated about 1120, whilst the chancel and nave are one hundred years later, at which date we lose the Norman characteristic work, and enter into the Early English style. This merging of the Norman into the Transitional period is distinctly shown both in St Giles Church and in the Chapter House of the Cathedral; where, although the entrance is a good example Norman doorway, the interior is Early English. We shall later treat of the modern churches in the City recognising this as a fitting time to close the peril that may fairly be described as 'ancient.'

OSNEY ABBEY

This Abbey, dating from the same early period, cannot be omitted from any history of Oxford. It must have had a very imposing appearance, and grew to be very wealthy, it being described as 'the envy of all other religious houses in England and beyond the seas.' In 1129 it was built by D'Oyly the younger in a modest style, but being rebuilt in the following century it increased so greatly in its grandeur that it was often made the abiding place of the royal visitors to the city. It fell into use as a prison in the days of Wolsey, students being confined there for reading the Bible. Marshall in his *Diocesan Histories*, speaking of the Abbey in its early days, says that 'the estates belonging to it had been returned at the annual value of £654 10s 2d,' equal to about twelve times the same value at present day. The Abbey stood at a short distance from the west end of St Thomas's Church, and had a chapel of such grandeur and size as to be selected in 1542 for the Cathedral Church of Oxford. It is described in an old document as 'a more than ordinary excellent fabrick, and not only was it the admiration

Osney Abbey.

of the neighbours, but foreigners that came to the University for the architecture, which was so exquisite and full of variety of workmanship, as carvings, cuttings, pinnacles, towers, etc., was so taking that out-landers were invited to come over and take draughts of it. Nor was it inside less admirable, the walls being adorned with rich hangings, the windows with awful paintings, the pillars with curious statues and images, the floor with speaking monuments, and all other places with rarities, reliques, etc.' The glory of the Abbey, as the Cathedral, only lasted, however, for three years, for in 1545, Henry VIII with his characterisic changefulness, transferred the bishopric of St Frideswide's, the present Cathedral, and the ruin of Osney began. 'Its two high towers, its fine hall, infirmary and dormitory, its spacious lodgings, its house erect for indigent people, who lived upon the offal that came from the monk's table, its tannery, brewery and bakehouse all passed away,' there being hardly a single stone left to show where the great Abbey once stood. The ruins are said to have been largely used by Wolsey in building his College (Christ Church). All that

generally known to exist today of its ancient grandeur is some portion of the altar plate of the Cathedral, the great bell in Tom Tower, and the Cathedral peal bells.

The story of the foundation of the Abbey as record is of great interest, helping us to realise the superstition of the age. 'D'Oyly had married an Englishwoman named Edith Forne, a previous mistress of Henry and who had given her the Manor of Claydon as dower. She was walking one day in the riverside meadows that lay outside the walls to the west of the castle, with her father-confessor, Ralph. It was spring morning, and the jays or magpies made a great chattering in the branches. The lady asked her adviser, who understood the language of birds, what their noise meant, and Ralph replied that the seeming birds were but poor souls in purgatory, who thus expressed their pains. The transition of ideas was easy; how could their sad state be remedied, what good work could the lady do to give them ease? Ralph was at her elbow to suggest the building of a religious house, and so Robert D'Oyly yielded to his wife's entreaty and built the Priory of Osney.'– Faulkner's *History of Oxfordshire*.

JEWS SETTLED IN OXFORD

The Jews, who were first admitted to England by William the Conqueror, were, by special grant of William the Second, allowed to establish themselves at Oxford; and to them is attributed the chief credit of advance at that period in science and medicine. A special district was allotted to them in Oxford, called the Great and Little Jewries, occupying part of the site of Christ Church and the City Buildings, in which they had a synagogue. A plot of ground was also assigned for their cemetery outside the East Gate; the present site being the Botanical Gardens and the roadway in front, at the foot of the Bridge. Skeletons have been dug up as recently as 1899 in laying new sewers in the roadway. In process of time they became possessed of three 'halls' or lodging-houses, for the accommodation of students, where they taught Hebrew to Jew or Christian alike. Increasing rapidly in numbers and

in wealth they soon became a source of anxiety to both University and City. In 1244 matters became serious upon students breaking into Jews' houses and carrying off valuable plunder; the magistrates of the City imprisoned the offenders, but they were released by the order of the bishop. Breaches of the peace nc became of frequent occurrence between the studen and the Jews, and in 1268, on Ascension Day, a serious affair took place, for which the Jews were called upon to make reparation. Prince Edward being in Oxford on a visit, the Chancellor and the whole body of the University were going in procession to the relics of St Frideswide, when the Jews offered a deliberate insult the Cross. Records show that they had no hesitatii in shewing their contempt for Christian doctrine ai ceremonial, which produced retaliation in the nature Jew baiting and attacks on the Jewry. These seen lasted until Edward the First expelled them from the kingdom in 1290; but, notwithstanding, the advance some branches of education must be credited to the settlement at Oxford.

OXFORD MONASTERIES

With the coming of the Friars to England in 1224 a new feature was introduced into the religioi and educational work of student life. As the Cistercians had come in the Twelfth Century to reform the Benedictines, so the Friars came in the Thirteen to reform the Cistercians. These two orders sought spiritual perfection in isolation; in working out their own salvation they paid little attention to the salvation of their fellow men. In the retirement of their splendid houses, on the fairest sites in England, they entertained noble travellers, and became agriculturalists, librarians and chroniclers; but they had nothing in common with the towns and little with the town people. The Friars at first were an entire contrast to these; they mingled with the meanest and poorest, and settled in the most squalid slums, wearing gowns of serge tied round with rope. They begged their way from town to town, setting up their portable pulpit in market place or village green. But the care and interests of the poor was not the only object of the

Franciscans. They were great promoters of learning, and 'their presence at Oxford was signalised by their efforts to enlarge the sphere of education, and to effect a systematic study of theology.' The Austinian Friars, who came to Oxford about 1268, took a prominent part in the studies of the students, and became celebrated for their success in teaching theology and philosophy. Their discussions and lectures are said to have attracted crowds of students, and had such influence that they became part of the University Course; so that before the students were allowed to take a degree a certain number of *Disputationes ad Augustinienses* had to be attended. Their site is at the present time occupied by Wadham College, where they had a fine church of stone from Headington Quarries, with the timber from Shotover Woods. The Dominicans, or Black Friars of St Dominic, settled in their house and church in the low-lying meadows by the Thames, on the west of Grampound (Grandpont) Bridge. On the Black Friars followed the Grey Friars of St Francis, and the story of their journey to Oxford is graphically told by a later writer of their own Order, and is quoted by Anthony Wood, the Oxford Antiquary:

'As they journeyed from London to Oxford, they wandered out of their way like innocent and harmless wretches, and being about six miles from Oxford, found themselves in a most vast and solitary wood near Baldon, with the floods out and night falling. Stumbling along in the darkness they came upon a lonely grange belonging to the Benedictine Monks Abingdon, and humbly knocked at the door, desiring for God's love to be given entertainment for the night. The monks, judging from their dirty faces, ragged clothes, and uncouth speech, took them for jesters and brought them in that they might quaff and shew sport to them! But the Friars, looking gravely up them said "that they were not such kind of people, but the servants of God, and professors of an Aposto life." They were thereupon vilely spurned and thrust out of the gate by the disappointed monks.' They built their house at the back of St Ebbe's, bound on the south by Trill Mill Stream, and it lay between the south or water gate and

a small postern near the castle, through which a road led across the Trill Stre: to the Black Friars. Their property and buildin grew so largely by benefactions that at the time of the Dissolution it was inferior only to Osney and St Frideswide. In *Diocesan Histories* it is stated the the Franciscans had a large foundation at Oxford, with a magnificent church 316 feet in length, a proportionate breadth, and ten chapels on the north side. Wood says the Friary must have been a pleasant place enough, with the buildings, courts, a pleasant grove five acres, a garden called Boteham, and the orchard or garden called Paradise, and pities the 'poore Fryers who were turned out and put to their shifts.' The site is still called Paradise Square, on which is the Rectory House of St Ebbe's Parish. After the Grey Friars came the Carmelites or White Friars, whose first house was in Stockwell Street, where Worcester College now stands; but a grander home was soon found for them through the smartness of one of their Friars, named Baston, who was attached to the suite of the King, as a poet. He was with Edward II. at the flight from Bannockburn, when the King commended himself with a vow to the Virgin, and on the suggestion of the Carmelite, promised if he left the field alive to provide the White Friars of Oxford with a better house. He afterwards redeemed his promise by presenting to the Order his royal palace of Beaumont, on the site of the north side of the present Beaumont Street, near Worcester College. The Royal Chapel became the Friary Church and had a fair steeple and a peal of bells. This also came down at the Dissolution and the whole palace destroyed except the refectory, which was converted into a poor house, and eventually demolished in 1596. Besides these greater Orders of Friars, three others of less importance had houses at Oxford; the Trinitarians, who had a house outside the East Gate; the Penitentiarians, having a house outside the West Gate; and the Crutched Friars, who had a house near Grandpoint, and later near St Peter-in-the-East. The chapel of Trinitarians, at the East Gate, was used as a place of Sanctuary, and in it the Mayor of the City used to attend Mass on his return from London, after taking his

election oath at the Exchequer, after which he was conducted by the citizens to his own house.

TOWN AND GOWN FEUDS

The recorded history of these feuds goes back to the beginning of the thirteenth century; and it is as a consequence of these disturbances that, notwithstanding the Charters that had been given by the previous monarchs to the town, that eventually township became merely an appanage of the University with all its privileges abolished. At this date the University was in its infancy, but growing rapidly when, in 1208, a scholar killed a girl and fled from Oxford. An unsuccessful search having been made the scholar, the citizens seized two of his fellow-lodgers and hanged them. As a retaliation, the school migrated to Reading and Cambridge, and the Pope applied an interdict to Oxford, depriving it of spiritual comforts. After four years an appeal was made on behalf of the citizens to the Papal Legate in London, who, granting them absolution, exacted severe penance, and granted privileges to the University at the expense of the town. It was ordained that a student found in crime should not be subject to municipal authority, but should be handed over to the Chancellor for trial in his Court. This privilege the University frequently avail themselves of at the present day. Amongst other penalties that were also imposed it was enacted 'that all lodgings should be let for half the usual rent for ten years.' These conflicts were frequent occurrences, always producing the same result: the humiliation of the town, and acquiring of new privileges by the University. In 1248 the Corporation were compelled to agree to the payment of a heavy fine if any citizen were in future to assault a scholar; and the Mayor and Bailiffs were sworn on accepting office to 'preserve all the privileges of the University.' Notwithstanding all precautions these disturbances continued, bloodshed frequently taking place even within the walls of St Mary's Church, until matters reached a climax in the riot of St Scholastica's Day of 1354. The details, which seem to us today so impossible of realisation, are best given in Mead

Falkner's *History of Oxfordshire*, from which the following is extracted: 'Some students were drinking in the Swyndlestock Inn, near Carfax, and an assault on the landlord led to a tavern brawl, which was carried into the streets after the revellers had been ejected. John de Bereford, the Mayor, a heady and unpopular official, ordered the bell of Carfax Church to be rung. This bell was the recognised tocsin of the townsmen, and they flocked together at its summons to do battle with the clerks. The Chancellor de Charlton retorted by ringing the bell of St Mary's, an equally recognised declaration of war on the part of the University. Free fighting began in the streets during the afternoon, but the days were short, and darkness stopped hostilities before much harm was done. Next day the bells were rung again, and the fray was resumed on a larger scale. A band of some hundreds of roughs from the suburbs and country, who had either been invited by messengers of the citizens, or were prompted by a natural taste for riot and looting, broke into the City and carried all before them. They bore, it is said, an ill-omened black flag, and shouting, ' Slay, havoc, smite fast, give good knocks,' certainly seem to have acted up to their words. The town was completely triumphant; hall after hall was burst open and gutted, heads were broken, chaplains were scalped (if we are to believe Wood), the Blessed Sacrament, which was being carried by the Grey Friars as a pacifying influence, was itself treated with contumely, and a great many of the scholars, and some of the townsmen, too, were left dead in the streets. But in the midst their triumph misgiving fell upon the citizens, and an order was put forth by by the leaders to stop all further attacks on the scholars. But the town was deserted, the scholars had fled en masse, and a Master of Arts sped to Lincoln to lay the tale of outrage before the Bishop. Vengeance was speedy and complete; the town was laid under the 'greater' interdict, and the King took the privileges of both the University and the town into his own hands. The University received its privileges back within a week, and was shortly reinforced by a new Charter. To the Chancellor was given the assessment of taxes, the control of

the streets, the "assize" of bread, beer and wine, the "assay" of measures and weights, and, in fact, the general management of municipal affairs. The Mayor was lodged in the Marshalsea; the Corporation was condemned to pay a very heavy sum to the University by way of indemnity; and the Mayor the Bailiffs and sixty of the principal citizens had to attend each year on St Scholastica's Day a solemn mass, for the repose of the slain, at the University Church. They were in addition to pay at least a penny each as contribution on this occasion in aid of poor scholars, and this humiliating custom lingered on into the reign of Charles II.' Matters remained in this position for a century and a half, until in the beginning of the sixteenth century the citizens began to assert their rights. They refused the customary penance at St Mary's and claimed the privileges of citizens. The University appealed to Wolsey, and it was by his aid that 'the refractory Corporation were brought to a proper state of subjection'; the Cardinal having obtained from the King a new Charter giving to the University the entire management of the trade of the town, and the right of himself to try all cases in which a member of the University was concerned, with no appeal to be allowed against his decisions; upon receipt of which, in 1528, the citizens made their submission to this further humiliation. Wolsey's fall and retirement having taken place the following year (1529), the Mayor in 1530 refused to attend and take the oath, for which he was excommunicated, his sentence being published in the parish churches. When the mass was abolished at the Reformation, another attempt was made to evade the humiliating ceremonial, and it was omitted for fifteen years, when the University entered action against the City for its restoration, resulting in a continuance of their attendance at a litany at St Mary's and the payment of the pence. This ceremony, in a modified form, was continued until the year 1837, when Mr Isaac Grubb was chosen Mayor, having stipulated that he would refuse to take the oath. The University were authorised by Convocation to take proceedings, but after some litigation gave way, and consented to abolish the oath. Thus ended, after 500 years' continuance,

a custom which was most objectionable to the citizens, and which did not reflect any credit up the University.

Conflicts between the students and citizens are nc things of the past; the incorporation of University representatives in the Council of the City undoubtec affording the best means of removing any cause friction between the two bodies.

THE CAMERA

This fine building (formerly called the Radcliffe Library) was begun in 1737 and opened with great ceremony in 1749, by the trustees of the will of Dr Radcliffe, the founder. He also left £40,000 for its erection, besides endowments for the Librarian's salary and for the annual purchase of books. It

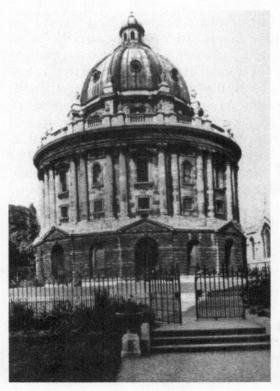

The Radcliffe Camera.

witnessed took place in this Library. On the 14th day of June, 1814, the Prince Regent, the Emperor of Russia, the King of Prussia, the Duke of York, and many other royal personages and nobility, to the number of nearly 200, were entertained here by the University in the most magnificent manner. It is said that the splendour of the fete could only be exceeded by imaginary scenes of Oriental description. The tables were loaded with elegant plate, the dresses of the company were superb, and many of them unique; as over their court dresses and regimentals, all the princes, noblemen, and gentlemen who had received the honorary degree of D.C.L., wore the scarlet Academic robes of that degree.

BODLEIAN LIBRARY

The commencement of the history of this world-famed Library is the room over the old Congregation House, at the east end of St Mary the Virgin Church, and is attributed to Thomas Cobham, Bishop of Worcester, and dated about 1320. The oldest portion of the present building is that over the Divinity School, founded by Duke Humphrey of Gloucester in 1445. Sir Thomas Bodley, of Merton College, it is said, 'found the walls bare, and not a volume of the previous stores remaining'; the Commissioners of Edward VI, having committed great destruction at Oxford. He refitted and restored it 1602, and in 1610 added the east wing. The numbers of MSS. are estimated at about 27,000, and the printed volumes, bound up, nearly 600,000, besides numberless old, rare, and original copies. The second floor of the quadrangle is partly used as a Picture Gallery; and contains besides, various models, busts, and curiosities. Many valuable books and manuscripts are exhibited under glass in the reading room. This Library, by agreement with the Stationers' Company in 1610, has had a right to a copy of every book registered with the Company since that date, and it is one of the five libraries which receive new publications under the Copyright Act. The rooms are open to the public daily, subject to a fee of threepence.

was built from the design of James Gibbs, a Scotch man, and a member of St Mary Hall. It is a circular building 100 feet in diameter, with a basement forming a double octagon, and a superstructure of Corinthian style, surmounted by a lofty dome with cupola, supported on a continuous arcade of circular arches. The basement is now enclosed and with the room above contains nearly 200,000 volumes, principally of works published since 1831; the original library of medical books having been removed in 1861 to the University Museum. The dome is 80 feet from the floor of the Library and is richly ornamented with stucco. Around the base of the dome it is encircled with open stonework, and from this height of 100 feet a magnificent panorama of the whole of the city and many miles of the surrounding district can be obtained, the distance round the building being 170 yards. One of the most notable and magnificent pageants that the University has ever

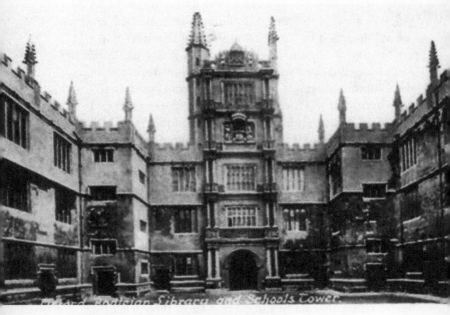

The Bodleian Library and Schools' Tower.

SCHOOLS TOWER

On the eastern side of this quadrangle is the gateway known as the Tower of the Five Orders, built by Thomas Holt, *c.* 1620, and carefully refaced in 1882 at a cost of £6,000. It is an extreme interesting example of medieval work, ornamented with pairs of Tuscan, Doric, Ionic, Corinthian, and Composite columns, with a sitting statue of James the First presenting copies of his works to the University. In the tower of this gateway the records of the University are kept.

THE DIVINITY SCHOOL

This is a magnificent room, built in the Perpendicular style and completed in 1480, principally through the munificence of Humphrey, Duke of Gloucester, and Thomas Kemp, Bishop of London. The oak work is dated 1669, and in 1702 it was restored, and extra buttresses built on the south side. It had originally very fine stained glass windows, which were destroyed in the reign of Edward VI., leaving the splendidly groined roof – its principal feature of beauty, adorned as it is with elaborately carved pendants and shields of arms. This room was the scene of the trial of Ridley and Latimer when brought before the Commissioners to answer for their heresies, 'so openly maintained by them at Oxford'; here also the House of Commons held its sittings in 1625, when driven from London on account of the plague; and during the Civil War it was used as an armoury and storehouse for corn.

MODERN OXFORD

The recorded history of the City of Oxford has now reached a thousand years. From the earliest records it has been linked together with London in its associations with royalty, and at the present time the Charter still provides 'that the Mayor of the City of Oxford shall be assistant-butler to the Mayor of London at the Coronation feast.' Kings and princes have had their palaces, and held their courts and parliaments here; and in the present generation our royal house has honoured Oxford by sending their sons to this University for their

education. During the last six centuries the rapid growth of the University, with its beautiful buildings and educational advantages, has materially altered its features, the result of which has been that during the last half of the nineteenth century Oxford made marvellous progress. Many things have contributed to make Oxford the beautiful City is today, and to give to it that worldwide renown the 'City of Learning.' Add to these things its beat and the beauty of its surroundings, and we can but wonder at finding a present day writer expressing himself as Meade Falkner does in his *History Oxfordshire*, recently published – 'That it is the most beautiful City in the United Kingdom few unbiassed persons will be found to deny – many will say that is the most beautiful in Europe – and when to beauty are added its intellectual facilities, its easy distance from London, and the pleasant associations of a young and healthy life, which have on most constitutions a vigorating influence, the great increase in residential population is easily accounted for.' In 1801 the population was 12,279, and in 1901 it has increased to 49,413.

One of the latest developments of its municipal life and one that is unique to the City of Oxford, is the recent appointment by its Council of a Committee for its own body, who have power to co-opt othe members from outside the Council, as a Visitors' Committee. That the voluntary services rendered by the body are appreciated is abundantly proved by the large increase of visitors who, year by year, come under the organisation of this Committee (See advertisement Visitors' Committee).

THE HIGH STREET

O ye spires of Oxford! domes and towers !
Gardens and groves! your presence overpowers
The soberness of reason; till, in sooth,
Transformed, and rushing on a bold exchange,
I slight my own beloved Cam, to range
Where silver Isis leads my stripling feet

Pace the long avenues or glide adown
The stream-like windings of that glorious street,
An eager novice, robed in fluttering gown
 —Wordsworth

This, the principal street of the City, has been frequently quoted by authors as one of the most beautiful streets in the world. Sir Walter Scott, writing of it in his *Provincial Antiquities,* says, 'It cannot be denied that the High Street of Edinburgh is the most magnificent in Great Britain, *except the High Street of Oxford.*' *The Daily Telegraph,* in an article in 1872, says, 'The visitor here beholds the finest sweep of street architecture which Europe can exhibit. For stately beauty, that same broad curve of colleges, enhanced by many a spire and dome, and relieved by a background of rich foliage, is absolutely without parallel.' Since the date at which this was written two blocks of new handsome buildings have been erected, further increasing its beauty – the new Examination Schools, which have been built at a cost of £100,000, and the new front to Brasenose College, immediately adjoining the University Church. Fortunately for the harmony of the buildings, both these important works were carried out from the designs of Mr T. G. Jackson, R.A. The Schools, being an excellent example of English Renaissance, and the Brasenose front, with its tower, entrance gateway, and fine range of oriel windows, have added much to the beauties of 'the High.' The length of the street is 2,300 feet, it being 80 feet wide, and, what is much greater importance in regard to its further improvement, is that both the City and University with each other in the present day to enhance beauties by rebuilding in accordance with the best characteristics of the street, and in further wideni the thoroughfare.

GOVERNMENT OF THE CITY

Henry II, in 1161, granted a Charter to Oxford, the preamble of which he professes only to confirm the liberties which the place had enjoy under Henry I. By a new Charter, given by Richard I, Oxford was given the same laws and liberties

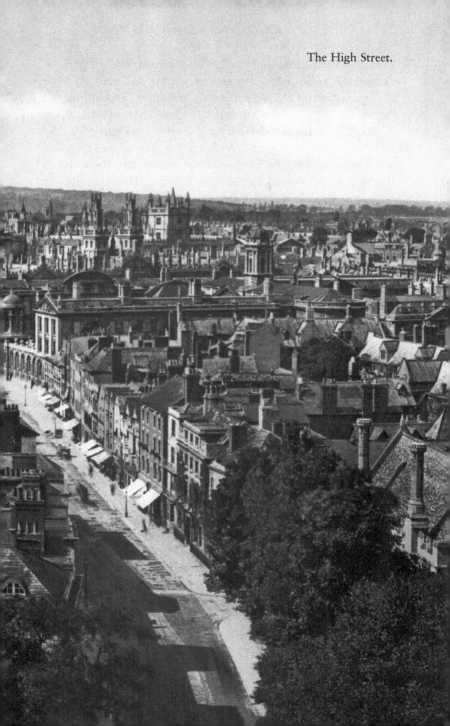

The High Street.

were enjoyed in London, the Guilds were established and the Corporation allowed to levy all kinds of tax and dues. Richard also gave the town a Mayor a two Aldermen, and appointed the Mayor to be sub butler under the Lord Mayor of London at the Coronation Feast. By a Charter of Henry III, the Aldermen were increased to four, and the Mayor was required to be presented to the Barons of the Exchequer, the same as the Mayor of London. In the time Edward III, it is recited in a Charter that all pleas relating to matters, real and personal, arising in the town or its liberties are to be determined before the Mayor and Bailiffs. Some few years later, in 1354 occurred that great conflict between the University and town which resulted in an 'interdict' being laid upon it, the privileges which had been granted to it were taken away, and a new Charter was granted to the University, giving to that body not only the general management of the municipal affairs, but the entire control of the trade of the town, the Mayor also being imprisoned, and the Corporation compelled to pay a large indemnity to the University. Several centuries passed by before the Corporation succeeded in fully recovering its privileges and freeing itself from the humiliating penalties that were imposed upon it. [This era of its history is dealt with more fully under the heading of 'Town and Gown Feuds.'] It was as recent as 1858 that the Mayor succeded in freeing himself from taking the oath of fealty to the University, in the words 'do swear to keep the liberties and customs of the University.'

Under the Municipal Corporations Act of 1835, the City Corporate Body was remodelled. It was then to consist of Mayor, Sheriff, 10 Aldermen and 30 Councillors, the City being divided into four wards. This body lasted until 1864, when the body was named the Local Board, consisting of the Vice-Chancellor and Mayor, 16 members elected by the Corporation, 17 by the ratepayers, and 15 by the University. In the year 1889, under the Municipal Corporations Act, the Council was again reconstituted, having the powers of a City Borough Council conferred upon it. It now consists of 60 members – one-fifth of whom represent the University; viz.: the

Mayor and Sheriff, 12 Aldermen, 36 elected representatives of four wards, and 12 elected representatives of the University (three of whom are elected from their own members as Aldermen).

The Mayor and Sheriff are elected annually, the Aid men for terms of six years, and the Councillors retire by rotation after each three years' service.

MUNICIPAL BUILDINGS

This very fine block has but recently been erected and was opened with much ceremony by His Majesty the King (then the Prince of Wales) May 12th, 1897. The style of architecture, which is a combination of Elizabethan and Jacobean, is in entire accord with much of the new work in Oxford, and affords additional beauty to St Aldate's Street, without reflecting on the beauties of Christ Church, situated just below it. The front elevation is arranged in three portions, the central block being carried up above those on either side, and treated more elaborately: the front of this block is divided into three bays, the lower part consisting of three semi-circular arches, the centre one being the entrance; those on either side enclosing windows. Between this and the upper windows is broad scroll running the whole length of the building. The Assembly Room is over the entrance, shown the three large mullioned windows, flanked by octagonal towers, finished with capping and vanes. The space above the windows has a cornice and open balustrade, connecting the turrets with an ornamental gable adorned with the statue of Queen Victoria and the City Arms, and crowning this is an octagon cupola with vane. The two other blocks flanking this on each side are of four windows of the same semi-circular arches, with two fine oriel windows above, and dormers above these, each with three lights, and elaborately finished semi-circular gables; whilst at the angle over the entrance to the Public Library is a larger turret, of similar design to those in the centre. The whole of the work is of Clipsham stone, from the designs of Mr. H. T. Hare, of London, upon whom the work reflects the

greatest credit. The cost to the City was between £90,000 and £100,000. One important and valuable consideration is that it provides accommodation for the whole of the working staff of the City Council, including the offices of the Medical and Sanitary Inspectors. It also includes the Sessions Court, with Jury Rooms, Police Station, and Drill Hall, and even the large Public Library of three floors.

THE TOWN HALL

This is approached by a fine stone staircase into an arcaded upper hall, surrounded by a dado of polished Hopton wood, stone and marble. The ceiling is vaulted in enriched plaster, and the windows are fitted with stained glass containing various coats of arms.

The Hall itself is a grand room of 110 feet by 55, surrounded on three sides by galleries, and at the east end is an orchestra with accommodation for 200 performers, and a grand organ by Willis, of Camden Road, London, furnished at a cost of about £2,000. It has been built and decorated in accordance with the best style of Renaissance work, the beauty of the ceiling and gallery fronts being particularly noticeable; its seating accommodation is nearly 2,000. The contrast upon entering this room after visiting the old College buildings cannot fail to surprise and gratify the visitor, a is a fitting finale to a day's visit to the City.

THE ASSEMBLY ROOM

This is a fine lofty room, 64 feet by 32 feet in width, and situate in the centre of the building fronting St Aldat Street, being immediately over the principal entrance. The oak panelling, which is a noticeable feature of the whole of the buildings, harmonises exceedingly well with the style of the room. An Elizabethan fireplace constructed in stone and marble, is set off with artistic minstrels' gallery above it. The room capable of accommodating about 600 persons. Adjoining and opening from this room is the Committee Room, and immediately adjacent the Mayor's Parlor in both of which the characteristics of the Assembly Room has

been thoroughly exhibited by the architect. The fireplace in the Mayor's Parlour was saved from the old building, and adapted to its new surroundings, whilst above it is particularly noticeable a fine old piece of oak carving.

THE COUNCIL CHAMBER

This has been specially constructed to accommodate the number of members under the new Corporate Act. It is excellent in its every detail; its oak panelling, windows, ceiling, and strangers' gallery all being in entire accord with the other parts of the building; the comfortable roomy seating accommodation for its sixty members being very noticeable. The high windows are calculated to show off the beautiful ceiling, and portraits of many of the former benefactors of the City.

THE DRILL HALL

Immediately under the Town Hall is a large room of 71 feet by 55 feet, which is; as its name implies, used for drill purposes of the Police Force; whose quarters immediately adjoin. It is also used for shows and catering for large parties, it giving seating accommodation for 550 persons. There is a large corridor adjoining of 10 feet wide, giving separate access from Blue Boar Street.

THE PUBLIC LIBRARY

This is situate at the south corner of the main building. The approach to this department is by a stone stairway, leading to the principal reading room, capable of allowing 200 readers at one time; the ladies' room, and the lending department. The Library has made rapid strides since its opening in 1854, after a poll of the ratepayers had declared in its favour. It has a very fine room on the second floor, which is used as the reference department; and the basement during nine months of the year is used as a children's reading-room, from 5 p.m. to 8 p.m., both sexes being admitted under fourteen years of age. This step has been adopted experimentally during the last two winter seasons, and has proved so very successful, at a small cost, that it is improbable, it will ever be discontinued.

MARTYRS MEMORIAL

This monumental statue of the Decorative style building is erected at the, northern end of the Churchyard of St Mary Magdalen, facing the broad thoroughfare of St Giles. It was designed the late Sir Gilbert Scott, R.A., on the model of the Eleanor Cross at Walham, and is beautiful both in design and in execution. It is 72 feet in height, including a basement of steps, and was erected in 1841, a cost of £5,000. The amount being raised by public subscription as a protest against the Tractarian movement, which was then very vigorous, encountered a great deal of opposition, but was successfully carried out. The statues and the niches are of Caen stone, that of Ridley facing Balliol College, Latimer facing Beaumont Street, and Cranmer facing St Giles. On the north side is the following inscription:

'To the Glory of God, and in grateful commemoration of His servants, Thomas Cranmer, Nicholas Ridley, Hugh Latimer, Prelates of the Church of England, who, near this spot, yielded their bodies to be burned; bearing witness to the sacred truths which they had affirmed and maintained against the errors of the Church of Rome; and rejoicing that to them it was given not only to believe in Christ, but also to suffer for His sake; this monument was erected by public subscription in the year of our Lord God, *mdcccxi*.'

At the same time as the erection of this memorial the Martyrs' Aisle was added to St Mary Magdalen Church adjoining, on the north side, in which was placed the door of the prison in which they had be confined, with its lock and key, the prison having been demolished in 1771. The memorial does not mark the spot on which the Martyrs suffered; this took place at or near a spot marked with an iron cross in the centre of the road opposite Balliol College, at the western end of Broad Street.

THE COLLEGES AND THE UNIVERSITY CHURCH

In his *Memorials of Oxford* Ingram says, 'According to the general accounts of history and tradition there was a church or chapel on this spot in the time of Alfred the Great, it being

positively said to have been built by him and annexed to the school, college, or university which he founded or restored after the ravages of the Danes. His place or royal mansion adjoining it, called by himself, in his Laws 'King's Hall,' corroborate the claims which have been advanced for the high antiquity of the place.' A variety of small chapels were in the course of time attached to the old church, many of which were entirely obliterated by subsequent alterations, but the names of some of them have been preserved, and are known as St Ann's Chapel, St Catherine's, St Thomas', the Royal, and Our Lady's (now known as Adam de Bronte's) Chapel. The Royal Chapel, now known as the Old Congregation House, is still an interesting relic. A deed executed in the year 1201 is said to have been 'given in our house of Congregation.' There is reason to conclude that it was built by Henry I; for in his Charter of Confirmation of St Frideswide's Church and Monastery in 1122 he describes this establishment as 'looking towards his own chapel.' From the earliest history of University life this Church has taken an important part; but whether it was Saxon or Early Norman as some authorities state, it was largely rebuilt just befo the close of the twelfth century.

THE OLD CONGREGATION HOUSE

This building, erected on the north side of the present chancel, is of the date 1320, and with the library over it, are attributed to Thomas Cobham, Bishop Worcester. It was restored in 1871. Adjoining, but on the other side of the tower entrance, is Adam Brome's Chapel, first Provost of Oriel College, rebuilt in 1328. The large altar tomb is that of the founder. Near this Chapel, under the Tower, are some of the oldest memorials in the building; the brass and inscription of William Hawksworth, third Provost Oriel, being dated April 8th, 1349. In the early days of the University, all its public functions were held in this building, including the meetings of Congregation, the granting of degrees, and the sitting of the Chancellor's Court; it was also used as the library and treasure-house.

THE TOWER AND SPIRE

The simplicity of this Tower is in beautiful contrast to the abundance of decorated pinnacles and niches, the largest of which are enriched with statues, 7½ feet height. The pinnacles are lined with a profusion pomegranates, in honour of Eleanor of Castile. Theight of the spire from the basement is 197 feet. It was erected about 1310, and rebuilt about 1490; it was again restored in 1861, and recently, it having been found that the pinnacles and statues at the base of the spire were in a dangerous state, a reconstruction was carried out by Mr Jackson during 1896–98 of the spire and decorative work, new figures being added, at a total cost of nearly £ 12,000.

THE CHANCEL

This is said to owe its foundation to Walter Lyhert, Provost of Oriel College, 1435–45, who afterwards became Bishop of Norwich. It is lighted by lofty windows reaching almost to the roof, and is still a beautiful specimen of fifteenth-century work. It has many old memorial slabs, amongst which is that of Amy Robsart, of Sir Walter Scott's 'Kenilworth,' who was buried at the east end of the Chancel in 1560; the spot having been accurately ascertained by Dean Burgon, he, in 1874, placed an inscription above it, which is to be seen at the foot of the altar steps. In 1674 Dr Bathurst, the Vice-Chancellor, gave, £300 to repair the chancel with black and white marble, the necessity for which is said to have been caused by the large number of royalist burials which took place during the Civil War.

THE NAVE

This is divided from the chancel by a modern stone screen, above which is the organ. At the beginning of the reign of Henry VII, the University, through the benefactions of others, built almost a new church, producing a magnificent nave and side aisles, following the line the earlier chancel. The nave consists of seven bays, lighted by spacious windows, both chancel and nave having open timbered roofs. On the north side of the nave is the canopied seat of the Vice-Chancellor, and the stalls occupied by the Heads

of Colleges, Doctors and Proctors. Amongst the many stirring scenes that have been witnessed in this church, none probably ha been more tragic, nor produced greater consternation amongst those present, than on that memorable occasion when Cranmer was brought here to publicly read his Protestant opinions. 'Having lifted up his hand in prayer,' instead of recanting he boldly repudiated all Romish doctrine as being 'contrary to the truth,' adding, 'As for the Pope, I refuse him as Antichrist.' Then followed great uproar, the preacher, Dr Cole, Provost of Eton, shouting 'stop the heretic's mouth.' The great west end window was filled with stained glass in 1891, in memory of Dean Burgon, Chichester, who was formerly Vicar of St Mary's.

THE PORCH

This magnificent entry from the High Street was erected by Morgan Owen, chaplain to Archbishop Laud in 1637, at a cost of £230. Its twisted columns and rich adornments are not only picturesque, but also unique, and blend beautifully with the character of the building. Over the porch is a statue of the Virgin and Child, which was defaced soon after its erection; and which was made one of the articles of impeachment against the Archbishop during his Chancellorship of the University, it being worded in the indictment as the 'Scandalous statue of the Virgin Mary with Christ in her arms.' It is recorded, that in 1642, when the Parliamentary troops, under Lord Save, were leaving Oxford they fired off their pistols as they marched away up the High Street, and shattered the heads of the Virgin and Child over the door of St Mary's and the image of Our Saviour at All Souls' Gateway. They would have done more damage but for the urgent remonstrance of Mr. Alderman Nixon and others of the townsmen. The porch and the figures were restored in 1865 by the late Sir Gilbert Scott.

The length of the church to the street is nearly 200 feet, it being 54 feet broad, and the height of the nave roof is 70 feet. Taken altogether it is probably the most beautiful feature of High Street.

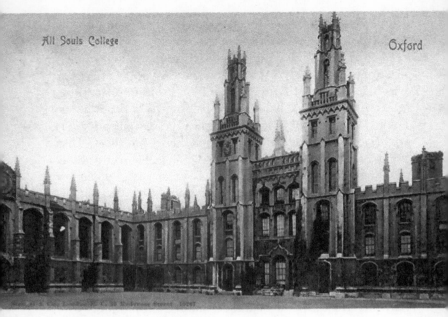

All Souls' College.

ALL SOULS COLLEGE

Founded by Henry Chichele, afterwards Archbishop of Canterbury, jointly with King Henry VI, and styled 'College of the Souls of all the faithful people deceased at Oxford' in the year 1437. The statues of both the King and Archbishop are over the entrance gateway in High Street, and also a canopied niche with a group of figures rising from the dead. The principal front, of over 250 feet in length, has entrance gates to east and west quadrangles, and is of two stories, with embattled parapet. It has also a western frontage to Catherine Street of about 450 feet, with a fine gateway of ironwork shewing the interior of the inner quadrangle, one of the prettiest of all the quadrangles of Oxford. The front quadrangle, 124 feet by 72 feet, remains very much as when first erected, with the chapel immediately opposite the entrance gateway. The inner new quadrangle, of 172 feet by 155 feet in breadth and formed by

the library on the north, which was begun in 1716, and was not finished for 40 years, and by the building of the cloister on the western side 1734. On the opposite side are the common-roor and fellows' chambers, relieved in the centre by two lofty embattled towers with pinnacles, in Gothic style. The very fine sun-dial, constructed so as to show the minutes, is dated 1633.

THE LIBRARY

This is called the 'Codrington Library' from the founder Colonel Christopher Codrington, Fellow of the College, who was a great benefactor, and bequeathed the sum of £10,000 and books of the value of £6,000. It is built in the Italian style, is 200 feet long, and contains with ease over 80,000 volumes; it has a gallery on three sides, and the ante-library has some stained glass of the same date as the foundation of the College. In addition to 24 busts, cast in bronze, of eminent Fellows of the College, there is also a fine statue in marble, by Bacon, of Sir Wm. Blackstone, and a statue of Colon Codrington, by Cheere.

THE HALL

This was begun in 1729, has handsome windows representing College worthies, and contains a large picture by Sir J. Thornhill, 'The Finding of the Law: King Josh Rending his Robe.' There are busts of Bishop Hebi and Archbishop Chichele, and numerous portraits, amongst which are those of Henry VI, Archbishop Chichele, Archbishop Sheldon, Archbishop Vernon, Colonel Codrington, and Sir Christopher Wren.

THE CHAPEL

This is approached by a vaulted passageway at the north-west corner of the front quadrangle. It is 70 feet long by 30 feet broad, and was consecrated in 1442. Its interior was wrecked in 1549 by the visitors of Edward VI, and its beautiful reredos destroyed.

Between 1664 and 1715, in the several restorations, the open roof was converted into a flat ceiling and decorated, and the battered reredos plastered over and painted with 'The Last Judgment,' by Robert Streeter, which afterwards had substituted for it the 'Assumption of the Founder,' by Sir James Thornhill. After the lapse of another 150 years since the last restoration, during which the existence of a previous reredos appears to have been forgotten, an accidental discovery of some fragments was made by men repairing the roof in 1870. A general restoration of the Chapel was made in 1872–76, the building being carefully restored under the care of Sir Gilbert Scott, including the removal of the ceiling and the construction of the reredos. This latter work, which is said to be the finest of its kind in this country, was executed at a cost of £3,000, which was defrayed by Earl Bathurst, who was at the time Senior Fellow of the College. It consists of three tiers of elaborately carved niches, containing 35 statues of kings and nobles, apostles, ecclesiastics, and fathers of the Church; and nearly 100 statuettes, including the leading characters of the Old and New Testament. In the apex, near the roof, is a representation of the Last Judgment, and over the Communion Table is represented the Crucifixion. The whole the carving was executed by Geflowski of London. Just above the altar are three richly decorated panels in relief, by Kemp, the subjects being the Deposition, the Entombment, and the Resurrection. The five windows on each side of the Chapel are in brilliant colours, and add much to the beauty of the building. The large west window of coloured glass in the ante-chapel is by Hardman. The 'Noli me Tangere' of Raphael Mengs, representing our Saviour's appearance to Mary Magdalen in the garden, now hanging in the ante-chapel, was at one time the altar-piece; the sum of 300 guineas was paid to the painter for this picture, being painted at Rome.

BALLIOL COLLEGE

The exact date of the foundation of the College is doubtful, but the year 1266 is assigned as its probable date. The statutes

of the foundation are still preserved and were compiled in 1282, bearing the seal of Dervorguilla, the widow of the founder, Sir John de Balliol, father of the King of Scotland of that name. The foundation is dedicated to the 'Honour of the Holy Trinity, the Virgin Mary, St Catherine, and the whole Court of Heaven.' The scholastic attainments of Balliol College have become very high during the last century; its students, in their examinations, securing larger proportion of 'firsts' than generally falls to the lot of individual colleges. This is probably largely due to the new departure of the college authorities in providing a larger number of 'open' scholarships and requiring higher merit to be shown in their matriculations, which has secured to this foundation higher merit than the average 'freshman.' Balliol College has a very extensive front both to Broad Street and from the Broad, north to St Giles, until it almost reaches St John's College. The rebuilding of

Balliol College.

the Broad Street front was completed in 1869, whilst the new west frontage, opposite the Martyrs' Memorial, was added in 1853. Entering the Front Quadrangle from Broad Street, we have facing us the library and chapel.

LIBRARY AND CHAPEL

The former was built in the middle of the fifteenth century, and amongst its treasures are several early manuscript editions of the Bible, and the original Statutes of the College. The original Chapel was dated 1529, the present building having been erected in 1857. The east window, representing the Passion, Resurrection, and Ascension, was presented in 1529 by Dr Stubbs, and was deemed so valuable at the time that Nicholas Wadham offered £200 for it, that he might place it in the Chapel of the College he was about to establish. The windows of Van Linge, of Flemish design, on the north and south aisles, are dated 1637, and represent Philip and the Eunuch, and Hezekiah's Sickness and Recovery; the other windows being portraits of Saints and Scriptural subjects.

THE HALL AND GARDEN

Proceeding through a small archway in the left-hand corner of quadrangle we approach the second quad on the north side of which is the New Hall, completed in 1876. The style of this second quadrangle is unique Balliol, it being the only one in the University that studded with large elms and chestnuts, beneath whose shade students may carry on their studies. The Hall is approached by a fine flight of steps, the basement being occupied by the Common Room, Buttery, and other offices. It is an exceedingly beautiful Hall, with fine windows and an organ presented by the late Master, Dr Jowett, at a cost of over £1,000. It contains portraits of eminent members of the college including the founder and his wife, Cardinal Mannin Dr Jowett, Robert Browning the poet, Archbishop Tait, and John Wycliffe, from the original Lutterworth who was Master of the College, 1360.

Brasenose College.

BRASENOSE COLLEGE

Having been erected in the reign of Henry VIII, cannot fairly be described as one of the ancient colleges, but this college, like nearly all the others, stands on the site of some of the earliest educational buildings, no less than five halls being merged at its foundation: Brasenose Hall, said to have derived its name from brazen-hus or brew-house; 'Little University Hall, which occupied the north-east angle near the lane being described by some antiquarians as 'one of those halls that King Alfred built.' On the south side stood Salisbury Hall, and further south, where the mode Chapel stands, Little Edmund Hall, the fifth being Edmund School. Four other halls were afterward purchased on the east side known as Haberdasher Hall, Black Hall, Staple Hall, and Glass Hall, three of which were afterwards surrendered to make room for the Radcliffe

Library. The foundation stone was laid in the south-west corner of the quadrangle in 1509, by Bishop Smyth and Sir Richard Sutton, and is called by the Charter 'the King's Hall and College of Brasenose.' The quadrangle remains in its original state except that a third storey was added about the time of James I, the hall and tower-gateway retaining much of their former grandeur and picturesque effect. The old frontage of the college occupies nearly the whole of the western side of Radcliffe Square; whilst a handsome new frontage, with an embattled tower gateway fronting the High Street, was erected in 1887, the four oriel windows adding much to the beauty of the street. The two quadrangles show a marked difference in character, partly due to the lack of space in the new one, but principally to the artistic effect introduced into the modern buildings. The College derives its name from old Brasenose Hall, existing in 1270, which is supposed to have been named from its knocker fixed in a nose of brass, which is perpetuated in the gilt nose over the entrance gate. The original 'nose' from which the name is derived was removed to Stamford, when, as Anthony Wood relates, the students migrated thither in 1334, endeavouring to establish another University, transferring the name of their Oxford home, taking with them the 'nose.' Until the year 1880 the knocker remained upon the door of the house they occupied, when it was removed for safety; and in 1890 the College purchased the property and recovered the relic, which had been lost to them for over five centuries; it is now treasured in the Dining Hall, being secured to the wainscotting. It consists of a large knocker-ring passing through brass face between the nose and mouth. The well-known piece of statuary, 'Samson Slaying the Philistine,' better known to Oxonians as 'Cain and Abel,' which stood in the centre of the quadrangle was removed in 1881, having stood there from the year 1727.

THE HALL AND LIBRARY

The Hall is entered through a curious porch, undoubtedly the original work, over which are two busts of King Alfred and

John Erigena, supposed date 1300. The former is said to have been discovered in the laying of the foundations of the College. The principal features of the Hall are a fine bay window at the upper end filled with painted glass and a massive chimney piece presented in 1760. Amongst many portraits are those of Bishop Smyth and Sir Richard Sutton, King Alfred and Lord Chancellor Ellesmere. The design the Library, which has been attributed to Sir Christopher Wren, is singularly interesting as a connecting link between the ancient and modern architecture. The interior was fitted up in 1780, a new arrangement being required through the large bequest of Principal Yarborough. Under the Library were formerly cloisters, a curious portion of which is still seen in the entrance to the Chapel.

THE CHAPEL

The present building was consecrated, having been ten years in building, in 1666; also from the designs of Sir Christopher Wren. It has a very fine east window, the old glass having been entirely replaced bv Mr C. E. Kemp in 1896, and several memorial windows also of stained glass. In 1894 the Chapel underwent partial restoration, and its roof and ceiling were given a great deal of attention, the latter receiving elaborate decoration and ornament. There is a very fine ante-chapel attached, which has an excellent window dated 1776, by Pearson, the gift of Principal Cawley, containing figures of Christ and the four Evangelists.

CHRIST CHURCH

This Society, which is much larger than any of the Colleges of Oxford, was founded by Cardinal Wolsey in the year 1525, and was called Cardinal College. Had he been able to carry out his original intention to provide for 200 scholars, an enlargement of the front quadrangle would have taken place on the north side. To provide the funds for his scheme permission was granted for him to suppress twenty-two convents and priories, including St Frideswide Priory with its revenue of £300 a year, and divert these revenues to his buildings. The Church of St

Christ Church College.

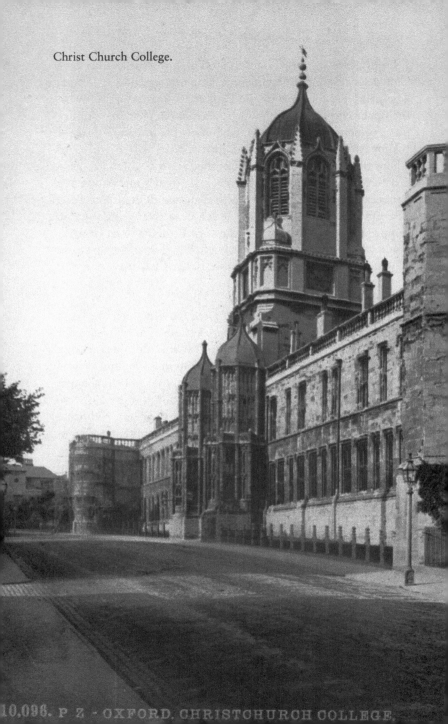

Michael, which stood at the south gate, was also destroyed to give room for the quadrangle: A patent was granted by Henry VIII, dated July 12th, 1525, for the foundation as 'AEdes Christi Thomae Wolsey,' and the foundation stone was laid on the 17th July, by Dr Longland, Bishop of Lincoln, with great pomp and ceremony, who preached from the text 'Wisdom hath builded her house.' The first portion built is said to have been the kitchen and hall, which adjoins the only portion that is left of the old building of St Frideswide, the building south of the Cathedral, which was the original Refectory, and was until 1775 used as the Library of the College. The rest of his completed work was the south and east sides, and part of the west front the quadrangle, including the Tower, named 'Faire Gate,' which was carried up to the level of the parapet; being afterwards completed by Sir Christopher Wren in 1682. Wolsey having fallen from the King's favour, in the year 1532. Henry VIII refounded the College, and named it King Henry VIII's College, dedicating it to the Holy Trinity, the Virgin Mary and St Frideswide, and endowed it with a revenue £2,000 a year. In 1546, a new patent was created by which it was re-established and connected with the new Bishopric of Oxford under the name of Christ Church; the Church of St Frideswide being made the Cathedral. The buildings remained in this unfinished state until Dr John Fell was appointed Dean (1660), and who was afterwards Bishop of Oxford; he attempted the completion of the north side of the quadrangle, succeeding in finishing the portion with the entrance at the north-east corner, and nearly completing the north buildings; but the Civil War breaking out meant they were left unfinished, and later were completed by his son, John Fell, together with the unfinished portion of the west front to St Aldates. His statue is over the north-east corner entrance, facing Wolsey over the hall entrance. He also employed Wren to complete the Tower, and place there the great bell from Osney Abbey, now known as 'Great Tom,' recast in 1680, and weighing nearly 18,000lbs, being 5ft 9ins high, and 7ft 1in. in diameter. It was first rung on May 29th, 1684, and every night since, as

a signal for the closing of the College gates, it has rung its 101 strokes at five minutes past nine; this number being the same number as the students of King Henry's foundation. By the north-east archway is approached another large quadrangle, called Peckwater, deriving its name from an ancient hall, the property of Ralph Peckwater, who gave it to St Frideswide's Priory in the reign of Henry III. Another ruin called Vine Hall with other buildings was added to it in the reign of Henry VIII, and were formed into a quadrangle in the middle of the seventeenth century. In 1705, the east, west and north sides were rebuilt after a design by Dean Aldrich, and made into the new quadrangle; the Library on the south side being begun in 1716 was not completed until 1761. A smaller quadrangle called Canterbury Quadrangle (from Canterbury College, founded 1363, by Simon Islip, Archbishop of Canterbury), was given to the College by Henry VIII. Between 1775 and 1783 this quadrangle was rebuilt chiefly at the expense of Dr Robinson, Primate of Ireland. The principal ornament is the magnificent Doric Gateway erected in 1778. A new range of buildings was added to the College in 1862–66, occupying a length of 350ft at a cost of £20,000, and overlooking the Broad Walk and the College Meadows. It consists of accommodation for 50 members with a central tower gateway 90ft high; the buildings being of three stories with dormes in the roof. The main front of the College to St Aldates, being Wolsey's foundation, is about 400ft in length, with a projecting wing at both ends adorned with oriel windows reaching to the parapet; 'Tom Gateway' in the centre being set back under dwarf projecting towers, with Wolsey's Statue above.

THE HALL

This building occupies nearly half of the southern side of the large quadrangle, which is 264ft by 261 – the dimensions of the Hall being 115ft long, 40 wide and 50ft wide. It is a magnificent room, and said to be only equalled by the Hall at Westminster; it was built in 1529, but having been damaged by fire was in 1720 repaired. The roof is of Irish oak profusely decorated with the

armorial bearings of Hen VIII and Cardinal Wolsey. The sides are half-wainscotted, having a handsome cornice with shields arms beneath. At the upper end is a very fine oriel window, filled with heraldic glass in 1867 by the late Archdeacon Clerke, in honour of the present King Edward and His Royal Highness the Crown Prince of Denmark, both Students of Christ Church. The window has also full-length portraits of Cardinal Wolsey, Sir Thomas Moore and other members. A very large number of portraits adorn the walls by the best masters, including Sir Joshua Reynolds, Vandyke, Sir J. Millais, Holbein, Gainsborough, Hogarth, Herkomer and Professor Richmond. Amongst recent portraits added are those of Dr Pusey, Dr Liddon and Mr Gladstone by the late Sir J. Millais. Among the numberless worthies who have made Christ Church famous from being educated there, we may mention few of the century just closed, with whom many living today were acquainted, *viz.*: Lord Canning, Lord Dalhousie, Lord Elgin, Lord Salisbury, Mr Gladstone, Lord Rosebery, Dr Pusev John Ruskin, Canon Liddon and Dean Liddell.

THE LIBRARY AND PICTURE GALLERY

This grand building, in Corinthian style, occupies the whole of one side of Peckwater Quadrangle. It was built from the design of Dr Clarke, Fellow of All Souls' College and MP for the University, and is 142ft long by 30ft wide; its fitting up being very fine and its ceiling richly ornamented, whilst its pillars and wainscotting are of Norway oak. The building was completed in 1761, and was repaired in 1829. The lower portion of the building is devoted to a Picture Gallery with statues and busts; whilst the upper floor has a very fine collection of books, manuscripts, and coins. In the Picture Gallery are several original specimens of early masters previous to painting in oils, including Madonna and Child between a Crucifixion, date 1300; Christ in the Temple (on wood); St Francis, 1273, and many others of equal interest.

THE BROAD WALK AND MEADOWS

This world-known Walk, in which during the present generation 'Show' Sunday, being the Sunday in Commemoration Week, was a great feature in the proceedings of 'Commem. at Oxford,' was made during the time of Dean Fell, about 1660. It is said that some of the old elms standing today were planted by his order. The waste materials from the buildingworks of both Wolsey and Fell were used for rais: the walk. Anthony Wood (born 1632), records the 'he had heard from old men that they used to row to Corpus and obtain drink from the buttery.' The Walk, formerly known by the name of the 'Long Walk,' is about a quarter-of-a-mile in length, with seats on both sides, and forms a delightful promenade. The New Walk, 600 yards in length, was made 1868, and leads to the Isis, the scene of the boat-race. The Meadows are a mile-and-a-quarter round, and with the exception of the Broad and the New Walks, are encircled by the Isis and the Cherwell, both being kept in excellent order at the expense of Christ Church. They are always open to the public, and are much frequented by visitors; the scene upon the river, especially during Term, being very attractive.

CORPUS CHRISTI COLLEGE

This is situated between Christ Church and Merton College Tower. It was founded in 1516 by Richard F. Bishop of Winchester, whose intention was to erect a seminary for a company of monks from the Monastery of St Swithun at Winchester; but acting under advice of Hugh Oldham, the Bishop of Exeter, altered his plans. Marshall's *Diocesan Histories* states that Richard Fox did not refuse to listen to advice of Hugh Oldham, who was more far-sighted than himself; for when he proposed to become a benefactor of the College, it was upon the condition he (Fox) abandoned the design of making it a home for monks, whose end and fate they might live to see, and make a College for secular students, who by their learning might do good to Church and Commonwealth! Bishop Oldham then contributed the

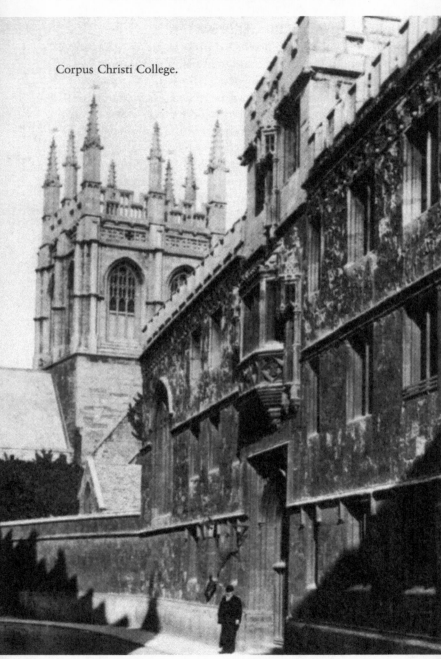

Corpus Christi College.

handsome sum of 6,000 marks towards the building expenses. The quadrangle, 101 feet by 80 feet, was completed in 1517, and embattled about 1609, another story being added on the north and west sides in 1737, with further restoration during the last century. The principal front is facing Oriel College, and consists of an embattled frontage of three stories, with a gateway tower of four stages. The front is ornamented with a good oriel window and rich canopied niches, with a curious piece of sculpture representing Angels bearing the Host. The beautiful tracery of the vaulted roof of the entrance gateway is very noticeable. A curious sundial stands in the centre of the quadrangle, designed by Charles Turnbull, a Fellow of the College in the sixteenth century.

Through the cloister is another more modern range of buildings overlooking Christ Church Meadows. They were erected in 1706, on the site of the old cloisters, by President Turner, at a cost of £6,000, being 119 feet in length. Extending from its south front is the. Fellows' Garden, in which on the south side may be found traces of the old City wall.

THE HALL AND LIBRARY

This has a good roof of Perpendicular work, but is an unpretentious building of 50 feet by 25 feet. It was re-wainscotted and ceiled about 1700, and again restored in 1857. It contains various portraits, amongst which is an original one of the Founder on panel, and those of various Bishops who have been connected with the College. The Library is rich in rare MSS. and ancient volumes, amongst which are some vellum copies printed in 1466.

THE CHAPEL

This was erected in 1517, and enlarged in 1677, and the floor re-laid in black and white marble, and a cedar wood screen set up. The east window is Perpendicular in style, and has a very fine picture by Rubens as altar piece, representing the 'Adoration.' It was presented to the College in 1804, by Sir Richard Worsley, formerly a member; who purchased it from

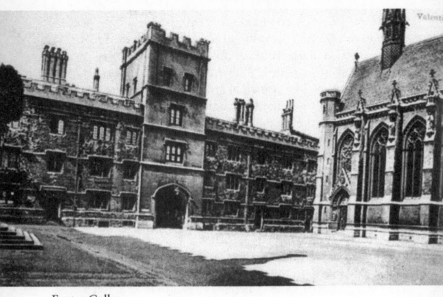

Exeter College.

the Prince of Conde's collection at a cost of £2,500. There is a very old eagle lectern, given by John Claymond, the first president, who died 1337, and whose brass, with effigy in a shroud, and twelve verses remains nearly perfect on the south side of the ante-chapel. At the east end is a gallery, between the chapel and the president's lodgings, containing the portraits of the seven Bishops committed to the Tower by King James II.

EXETER COLLEGE

The foundation of this College was under the name of Stapleton Hall, in the year 1314, it being founded by Walter de Stapleton, Bishop of Exeter, who removed hither his scholars from Hart Hall. In 1404, Edmund Stafford, Bishop of Exeter, altered the name to the present one, and established fellowships. Sir William Petre added largely to its endowment during the reign of Queen Elizabeth, and reforming the statute established it as a College in 1565. The main frontage to the College, situated in Turl Street, is 220 feet in length, having an embattled four-storey gateway

tower, which has been rebuilt on three occasions, 1595, 1703 and 1834; extensive repairs took place in the latter year under Mr Underwood's supervision, the whole front being re-faced. A large house was erected by Dr Prideaux, rector 1612–42, behind his house, for the accommodation of the foreigners who were attracted to the College by his great reputation, which was afterwards added to the College buildings. In 1856 a new quadrangle was added under Sir Gilbert Scott, with a northern frontage to Broad Street. This has also a gateway tower, the whole building being in Modern style, and is about 150 feet in length. In the Fellows' Garden, a secluded and beautiful spot at the back of the front quadrangle, are two noted trees: the large chestnut at the farther end being known as 'Heber's Tree,' as it directly overshadows the rooms of Brasenose College, occupied by Bishop Heber; and a fig tree at the entrance, known as Dr Kennicott's fig tree, the story being that on one occasion when the figs were ripe he attached a label 'Dr Kennicott's fig tree,' for which a wag substituted another label, 'A fig for Dr Kennicott.'

THE HALL AND LIBRARY

The Hall is a noble room, with fine timber roof, and was built by Sir J. Acland in 1618. It was last restored in 1872. Beneath the Hall is a Crypt, which has been attributed to St Mildred's Church, which formerly stood near this site, but during recent years it has been converted into a store-room. Amongst many notable portraits are those of Sir William Petre, Sir Walter de Stapleton (the founder), Charles I, Queen Elizabeth's Lord Justice Coleridge, Dr Mackarness (late Bishop of Oxford). The Library, which is in the Fellows Garden, was built in 1856, from designs by Sir Gilbert Scott. It is not so rich in old and rare works as many of the College libraries, many treasures having been lost by a fire in 1709.

THE CHAPEL

The original Chapel was built in 1326 for Stapleton Hall, and stood in the present Fellows' Garden. In 1624 a new Chapel was erected by Dr Hakewill, fellow of the College, at a cost

of £1,400, on the site of the present building, which gave way for the present magnificent Chapel, designed by Sir Gilbert Scott 1837–39, and built at a cost of nearly £20,000. It was designed after the style of the celebrated Sail Chapelle of Paris, the dimensions being: length, 91 feet; width, 30 feet; height to roof, 84 feet: its style being Decorated Gothic. It has been frequently and rightly described as a gem of beauty, for no one can behold the harmony of its many details in stained glass, its columns with carved capitals, its mosaic and marble, its fine roof and wood carving, without being struck with its extreme beauty. The principal feature of attraction was added to this Chapel in 1890 by the placing on the wall, near the altar, of tapestry hangings of extreme beauty, representing the 'Ador tion of the Magi,' with life-size figures. It was designed by Sir E. Burne Jones, D.C.L., and executed under the care of the late William Morris, M.A., both Honorary Fellows of the College, at the works of Morris & Co., Tiverton, near Wimbledon.

HERTFORD COLLEGE

Has an eventful but interesting history. Founded by Elias de Hertford, it was known as Hart Hall, and had existed as a hall for students from 1284. A Mayor of Oxford, named Sir John Docklington, purchased it in 1301 from the founder's son for £20, and in 1312 granted the lease to Walter de Stapleton, founder of Exeter College, who placed students there until his College was ready for them. It was afterwards used by William of Wykeham, founder of New College in 1379, for the same purpose. In the year 1740, the Rev. Richard Newton, of Christ Church, who was in 1710 appointed Principal of Hart Hall, obtained a Charter to convert the Hall into Hertford College; but principally on account of insufficient endowment it never flourished, and, in 1805, as no qualified person could be found to accept the office of Principal, the foundation ceased to exist, and the buildings having become ruinous, in 1818 its small endowment was granted to the sole remaining Fellow, Richard Hewitt, for life; after which it fell to the University. In 1816 a special Act of Parliament was obtained by Magdalen College,

by which they acquired the site of Hertford, and having erected two new blocks of buildings opposite the Bodleian, they occupied them in 1822, and renamed them Magdalen Hall. In 1874 another Act of Parliament was obtained by which the foundation of Magdalen Hall was dissolved, and the old name of Hertford College restored.

The buildings consist of a single quadrangle, which until 1888, were in two detached blocks of three storeys each, united by a high wall with rusticated gates; erected in 1820 by Magdalen College; but in 1878 a space of 80 feet was filled with buildings of somewhat similar character, but in elaborate style, the centre being occupied by an entrance gateway, having a low arch flanked by four fluted pilasters, with handsome capitals, and also adorned with a shield bearing the relief of a hart lapping at a brook. The dining hall a common room entirely occupy the first floor of this new building; the former being a fine room of 60 feet 27 feet, having an oak chimney-piece, beautifully carved, and oak wainscotting. A new set of building was erected in 1890, facing New College Lane, completing the quadrangle. The remaining building formed part of the ancient Hart Hall, and its successor, Hertford College, included in which is the Chapel, an uninteresting structure in Italian style, erected Richard Newton, the last Principal of Hart Hall, 1715. The old Hail on the north side contains portraits of John Tyndale, the translator of the New Testament; Lord Chancellor Clarendon, Thomas Sydenham the physician, and several bishops.

JESUS COLLEGE

This is remarkable as being the first College of Protestant origin, being established in 1571, on the site occupied by four of the old halls, Elm, Hawk, Lawrence, and White Halls. For a long time the buildings were poor and incomplete, until the appointment of Sir Leoline Jenkins as Principal in 1661, when, through his munificence it began its course of prosperity. It has, from its foundation by Dr Hugo Price, mainly drawn its students from Wales, although there is no provision by

statute that it should do so. Its foundation was of a very modest character, Dr Price giving estates of the value of £160 a year, which were allowed to accumulate to £700 before the buildings were commenced, Queen Elizabeth contributing timber from the woods of Shotover and Stow, and a portion of the site, including the religious house called White Hall. The College consists of two quadrangles, being immediately opposite Exeter College, facing both the Turl and Market Streets. The principal front was rebuilt in 1856 in the style of the sixteenth century, and has an embattled gateway tower, with turret. Over the entrance is an elegant oriel window, the front being completed with the eastern end of the Chapel. The inner quadrangle is larger than the front one, being too feet by 90 feet; its building was completed in 1677, and similarly to the front consists of three stories.

THE HALL

This is a spacious, lofty chamber and was given by Sir Eubule Thelwall. It has a very fine oriel window of 20 lights, projecting into the inner quadrangle, and also has an elaborately carved screen. The portraits include Queen Elizabeth, Charles I by Vandyke, and Charles II. Amongst the treasures of the College in the Bursary is preserved a silver-gilt punch-bowl, presented by Sir W. W. Wynne in 1772. It weighs 278 ounces, its height one foot, and its girth five feet two inches, holding nine gallons.

THE CHAPEL

This was built in 1621, was lengthened by additional chancel in 1836, and was carefully restored in 1864. It has appropriate motto over the entrance, 'Ascendat oratio, descendat gratia' (Let prayer ascend, and grace descend). Its east window, of the date 1636, is Late Gothic, and in 1836 was filled with stained glass representing the types and anti-types of Christ, the Resurrection of Jairus' Daughter, the Son of the Widow of Nain, and Lazarus. A former altar-piece, a painting ten feet by seven feet, representing St Michael overcoming Satan,

being a copy from Guido, and the gift of Viscount Bulkeley, has been removed to the south wall. The front and sides of the chancel are alabaster, relieved with marble columns, with an altar piece in relief, representing scenes of The Crucifixion. It has also a carved screen separating the ante-chapel with a decorated timber roof; whilst the floor is marble, relieved with decorated tiles, the altar steps being particularly fine.

KEBLE COLLEGE

This is the latest of the Colleges erected that is included in the University as a Corporate body. It is situated near the Church of St Giles, being opposite the University Museum; and was founded in 1868 as a memorial to the Rev. John Keble, author of 'The Christian Year,' and to promote plain living and doctrines of the Church of England. The site of about four-and-a-half acres was purchased from St Johns College for £7,000, and the foundation stone laid April 25th, 1808, by Archbishop Longley, of Canterbury, the first cost of building having been £50,000. The College was incorporated by Royal Charter in 1870, and on the 23rd day of June, was opened by the Marquis of Salisbury, the Chancellor of the University. The building is very much in the style of Early Gothic, but the free use of the coloured brickwork has imparted an appearance entirely distinctive from the other Colleges. The buildings consist of two quadrangles of variegated brick, with bath stone dressings; the entrance being through a gabled tower in the centre of the east front, supported by buttresses. The large quadrangle has a very striking appearance, no other College, excepting Christ Church, shewing the style of the raised broad terrace surrounding the grass plots, which are well set off at this College by the colour of the surrounding buildings.

THE HALL AND LIBRARY

The Hall is one of the largest in Oxford, being 127 feet by 35 feet. Both rooms are approached by a very fine staircase, having a lofty roof, and being lighted with an oriel window. The Hall has on one side a projecting gallery, supported by three arches;

it is panelled all round, and has traceried windows, with a fine timbered roof. The portraits include Archbishop Longley, Dr Pusey, Rev. John Keble, Dr. Liddon, W. Gibbs, Esq., the Bishop of Rochester, and others; whilst the Library contains busts of Dr Pusey and John Keble, by Richmond; and also of Cardinal Newman, by Woolner. The cost of erection of both the Hall and Library was borne by the Gibbs family.

THE CHAPEL

This is a superb building, entirely different from the style of any other Chapel in the University. It was built from the designs of Mr Butterfield, being completed in 1876, at a cost of £60,000, and was the gift of the late Mr William Gibbs, of Tyntesfield, near Bristol. It is 125 feet in length by 35 feet in wide and 95 feet high. The interior is of brickwork, the walls being adorned with Scripture pictures in colour mosaics, composed of marble, granite, and alabaster. The whole of the windows are of stained glass, showing the Prophets, Apostles and Evangelists; the windows being exceptionally high, making room for the panel mosaics below them. At the west end are the mosaic panels, exhibiting the Second Coming of our Lord, attended by Angels. In the centre, St Michael the Archangel, is dividing the saved from the lost. A small side chapel has been erected on the south side in which is placed Holman Hunt's great picture, 'The Light of the World,' which was presented to the College by the late Mrs Combe, of Oxford (cost £10,000). This picture was presented with a view increasing the income of the foundation, and therefore a small charge is made for admission to the ante-chapel; tickets for which are had from the porter at the gate.

LINCOLN COLLEGE

This College was founded in 1429 by Richard Fleming, Bishop of Lincoln, to counteract the influence of the teaching of Wycliffe, and was to be 'a little College of true students in theology, who would defend the mysteries of the sacred page against those ignorant laics who profaned its most holy

pearls.' It was originally semi-monastic, and rather a hostel for theologians than a College. It was built on the site of St Mildred's Church and Churchyard. Bishop Fleming dying before much was done for its establishment, the College fell into great straits for want of further endowment, and in 1478 Bishop Rotherham, who succeeded Fleming as Bishop of Lincoln, re-constituted it, obtaining another license from King Edward IV. The College was named after the See of Lincoln; Fleming's license from Henry VI stating that it should be known as 'The College of the Blessed Virgin and All Saints, Lincoln, in the University of Oxford.' The eastern part of the inner quadrangle was added about 1630, and an extra wing providing accommodation for fifteen students was added in 1882 on the site of the 'Grove,' at a cost of £9,000. The greater part of the College retains its original character, the oldest portion being the kitchen, which is said to occupy the site of an ancient Hall, dated 1300, which the thickness of walls, and its high open timbered roof seem to substantiate.

The entrance to the quadrangle from Turl Street is by an embattled tower gateway, with a groined roof. On the opposite side of the quadrangle, which is 80 feet square is the Hall.

THE HALL

This is a handsome building, built in 1436, and repaired in 1701 and 1835. The fine old timbered roof was covered in with a plaster ceiling in 1701, when it was refitted with new wainscot work; this plaster work being removed in 1889, it is now restored as it was originally built. Amongst many portraits are those of the founders, a Lord Crewe, Bishop of Durham, formerly Rector of the College.

THE CHAPEL

Situated in the second quadrangle, is a well proportioned Gothic building 62 feet in length and 26 feet in breadth. The whole of the interior is fitted with cedar wood, some of the carving being specially notable. It is dated 1631, having been built at the expernse of Dr Williams, Bishop of Lincoln,

afterwards Archbishop of York. The windows are particularly good examples, the colouring being remarkably distinct. It is said they were procured from Italy in 1629 by Bishop Williams. The large east window is divided into compartments, and represents Old and New Testament subjects, as types and anti-types: the subjects being the Creation of Man and the Nativity of Christ; the Israelites passing through the Red Sea and the Baptism of Christ; the Passover and the Lord's Supper; the Brazen Serpent and Christ on the Cross; Jonah delivered from the Whale and the Resurrection of Christ; Elijah in the Fiery Chariot and Christ's Ascension. The windows on the north side represent twelve Prophets, and those on the south side the twelve Apostles.

In the ante-chapel is Wesley's pulpit, from which he preached when a Fellow of the College; he was elected from Christ Church to a Fellowship at Lincoln in 1726.

THE LIBRARY

This deserves special notice, as it was the only College Library in Oxford that escaped the ravages of the Commissioners of Edward VI, when so many valuable works were so ruthlessly destroyed. It was first erected at the expense of Dean Forest; it was restored in 1590 and in 1656. In 1739 it was refitted, and it now contains many valuable MSS. and books, including a MS. copy of Wycliffe's Bible.

MAGDALEN COLLEGE

Anthony Wood says, 'Magdalen is the most noble and rich structure in the learned world,' and this statement made three hundred years ago is held by many to be equally true today. It was founded by William Fatten, of Waynflete, who in 1457 secured the site of the old Hospital of St John the Baptist, standing outside the City gates, being immediately adjacent to, or perhaps partly occupying, the old Jewish burying ground. This Hospital is supposed to have been the original foundation, and carries us back more than two centuries earlier than the foundation of the College; as between 1231 and 1233 Henry

III re-built or enlarged 'the Hospital leading from the east gate to the Cherwell,' over which was an ancient bridge in 1004. The Hospital continued under the name of Almshouse until 1607. The old doorway, called the 'Pilgrim Gate,' is still to be seen near the foot of the tower facing High Street, filled in with stonework. In consequence of the troublous times, however, and that Waynflete lost favour with the King, his chapel was not commenced until 1474, and at his death in 1486 his buildings were not completed. The new society being temporarily lodged in the Hospital buildings received their Charter of Foundation in 1548. Magdalen College from its foundation received a large amount of royal patronage; Edward IV in 1481 came from Woodstock to Magdalen, sleeping there and attending chapel service. Richard II also paid a visit two years later, and was much gratified with entertainment there. Prince Arthur, brother to Henry VIII, was several times entertained there. James also brought Prince Henry, heir apparent to throne, to Magdalen, and he was later followed Prince Rupert, nephew to Charles I.

The College is beautifully situated at the eastern end of the City, at the foot of Magdalen Bridge, being bounded on the east side by the River Cherwell, which runs into the Thames a short distance below. It has a frontage, 570 feet from north to south, and 330 feet to the High Street, but the beauty of its buildings are the interior quadrangles, which, with its Grove and Walks, occupy an area of nearly 100 acres.

At the entrance by the porter's lodge is St John Baptist Quadrangle, with its quaint stone pulpit in the corner, from which the old custom of preaching sermon on St John's Day has recently been revived in commemoration of the Baptist preaching in Wilderness; on which occasion the congregation assemble in the quadrangle and the ground is strewn with rushes and grass. Adjoining is the west doorway of the Chapel, adorned with the figures of St John the Baptist, St Mary Magdalen, St Swithun, Edward IV, and the founder. The splendid tower on the right is named the Founder's Tower, with statues of St Mary, St John, Henry VI, and the founder. On its first floor is a very

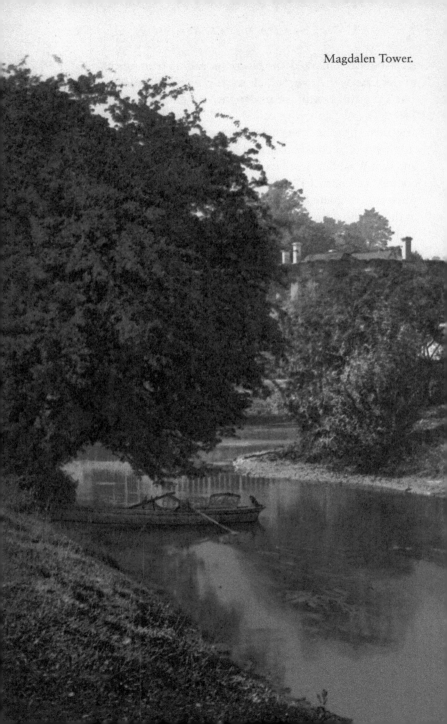

Magdalen Tower.

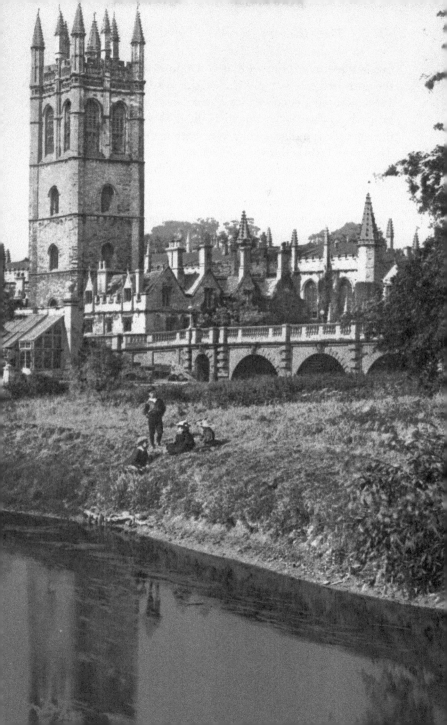

fine banquetting room with oriel windows at each end. Facing
the entrance gateway are the President's lodgings, rebuilt in
1888; adjoining which stands a remnant of old Magdalen Hall,
properly known as 'Grammar Hall,' it having been erected by
the founder as a school connected with the greater foundation.
The pretty little bell-tower still remains, and is said to have the
bell used in Waynflete's School. The new buildings on the west
side are St Swithun's Quadrangle, built in 1887, the new front
to High Street being nearly 200 feet in length. Entering the
inner quadrangle by way of the chapel entrance is the cloistered
quadrangle, the cloisters having been built in 1473, excepting
the south side, which were added in 1490; in 1822 they were
restored. A series of allegorical figures ornament the buttresses,
dating from 1509, and have attracted a great deal of attention
from antiquarians. Passing from the cloisters we find another
scene of entrancing beauty in the so-called new buildings erected
in 1733, with wide and splendid lawn in front about 300 feet
square, and the Grove, or Deer Park, at the further end. The
buildings are in the Italian style, the lower storey being a piazza,
with three storeys above. At the lower end is the Cherwell
stream, dividing the 'Water Walks' from the Gardens, a most
pleasant walk shadowed with trees, bounded by the river all
the way round, in which is the far-famed Addison's Walk. The
one other quadrangle, known as the Chaplain's Quadrangle,
is at the foot of the Tower, and the Tower being erected from
1492–1507, this quadrangle immediately followed, being built,
it is said, from the remnants of the old Hospital; the wall on the
right being part of the original building. The Tower is 150 feet
in height, consisting of five storeys, and crowned with a rich,
open battlement with eight pinnacles. On May-day morning
in each year at five o'clock, an old custom is still observed the
college choir singing the Latin hymn 'Te Dei Patrem colimus' on
the summit of the tower.

THE HALL

Built by the founder, and decorated with armorial bearings,
is a spacious and well-proportioned room of 73 feet by 30

feet. The date inscribed on the wainscot is 1341. It is adorned with oak panelling of linen-fold pattern, and at the west end has some remarkable carved figures, brought from St Mary's Abbey, Reading. A very fine window is also at the west end. Amongst a large number of portraits a fine picture of Mary Magdalen, by Guercino; Prince Rupert, supposed to be by Vandyke; the Founder, Prince Henry, Addison the Poet, Bishop Fox, Founder Corpus Christi College, and others. The kitchen adjoining is particularly interesting, it being supposed to be the original building of St John's Hospital.

THE CHAPEL

This is on the right of the entrance gateway, and is generally acknowledged to be one of the finest in the Universe. The foundation stone of the College was laid in the middle of the high altar, the building of the College, progressing outwards from the Chapel, the Chapel being completed in 1480. In the ante-chapel, which is separated from the choir by a fine stone screen, above which is a magnificent organ, there is a fine painting in chiaro-oscuro by Christopher Schwartz, representing 'The Last Judgment,' which was restored in 1794 by Egginton, by whom the other windows in the ante-chapel, were executed. In 1635 the inner chapel was paved with black and white marble, and the interior fittings and decorations renewed. It was also provided with a handsome screen, a new organ, and painted windows. In 1649 the stained glass and the building generally was seriously injured by the Parliamentary troops. In 1833, a general restoration took place at a cost of £18,000, the windows and the choir being refitted later with brilliant stained glass, and in 1864 the reredos was refitted with statues. There is a valuable painting, as an altar-piece, of Christ bearing the Cross, having doubtful authorship, it being traced back to one of the wrecked galleons of the Spanish Armada; and over the painting, in the apex, is a sculptured representation of Christ appearing to Mary in the Garden by Sir Francis Chantrey, R.A., altogether producing one of the handsomest eastern decorations of all the College Chapels.

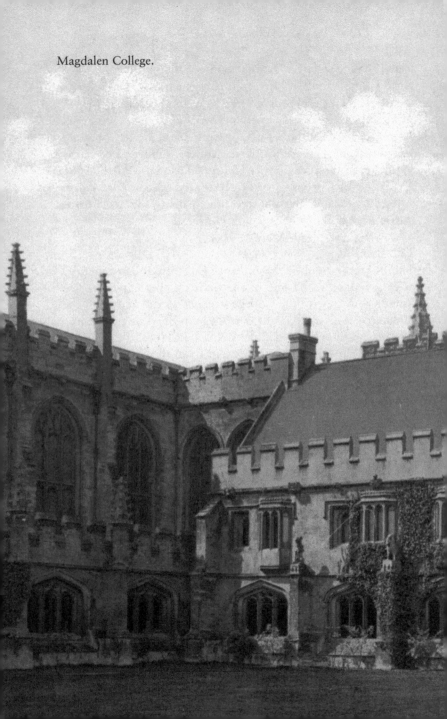

Magdalen College.

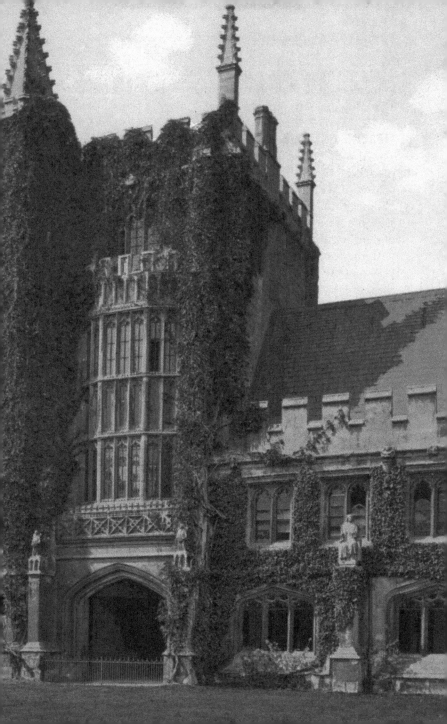

There is a monument in the small ante-chapel near the altar, in memory of Richard Patten, father of the founder, erected in 1833, having been rerfioved from Waynflete Church.

MERTON COLLEGE

The history of this College is of special interest, as exhibiting the model of all the Colleges of Oxford and Cambridge; the statues of Walter de Merton having been very much copied by all later founders. Previous to the time of this foundation the students were scattered in inns and halls throughout the whole of the City, and were under very little control. A new era began with the foundation of Merton College, and its example was very quickly followed, to the great advantage and comfort of the scholars. As an interesting example of the stringency of the new regulations we quote the following from Clarke's Colleges Oxford: 'By the injunction of Archbishop Laud it was ordered that the College gates should be closed half-past nine, and the keys given to the Warden; none being allowed to sleep in Oxford outside the College walls, or even to breakfast or dine. In 1508 the College itself legislated against the growing practice of giving out-college parties in the City, and coming late, "even after ten o'clock."' The first Charter is dated 1264, and was given by Henry III 'for the perpetual sustentation of twenty scholars dwelling the schools of Oxford, or wheresoever else learning shall happen to flourish.' In 1270 the founder ratified and confirmed his preceding endowment; and again in 1274 is a Charter approving of the two former Charters, with the seal of Edward I attached. In the following year to the first Charter the founder obtained a piece of ground 'about the Church of St John the Baptist' from the Abbey of Reading. A royal confirmation of the grant of the land was procured and license for the enclosure of the ground, 'for the better site of such his house of scholars.' Other properties adjoining fronting the street having been purchased, enabled the founder to complete a plan for a quadrangle with considerable frontage to St John Street, with the Warden's lodgings occupying the east side, the chapel the west, and the hall, with kitchen, butlery, and

other offices the south, with probably a small part of the small court now called 'Mob Quad.' The north side of the buildings, facing Merton Street, were altered about 1589, but the noble gateway, with its embattled tower, remains as built in 1416. In the front are two statues of Henry III and Walter de Merton, and immediately over the gateway a curious piece of work, representing John preaching in the Wilderness.

THE HALL

Approached by a flight of steps, this was so greatly altered a century ago that little more than the dimensions of its original structure can now be ascertained. The present porch was built in the reign of Queen Elizabeth, and the Hall was about the same time wainscotted with oak, similar to those of New College, and Magdalen, which was removed in the alterations referred to in 1800; in 1872 an attempt was made to restore it to its ancient character by the late Sir Gilbert Scott, at a cost of £6,000. The outer door to the Hall is said to be all that is left of the old structure of 1280, and is particularly noticeable on account of its hammered iron hinge mountings, dated about 1330.

THE CHAPEL

The chapel was until later years the Parish Church of St John the Baptist, which parish has now been incorporated in that of St Peter-in-the-East, leaving the College services alone to take place here. It is built in the Decorated and Perpendicular styles, consisting of choir and transept and a central tower. The choir, 110 feet in length, was begun in 1277, and has, beside the east window, fourteen others, seven on each side of extremely beautiful decorative work, retaining a great deal of the original glass. The east window is often described as being the pride of the chapel. The seven lights, executed by Price in 1700, show principal events in the life of Christ, the beautiful rose above exhibiting some old remnants and brilliant pieces filled in about 1850. In the altar-piece below the window a painting of 'The Crucifixion,' by Tintoretto presented by John Skip, a Gentleman

Merton & Corpus Christi Colleges.

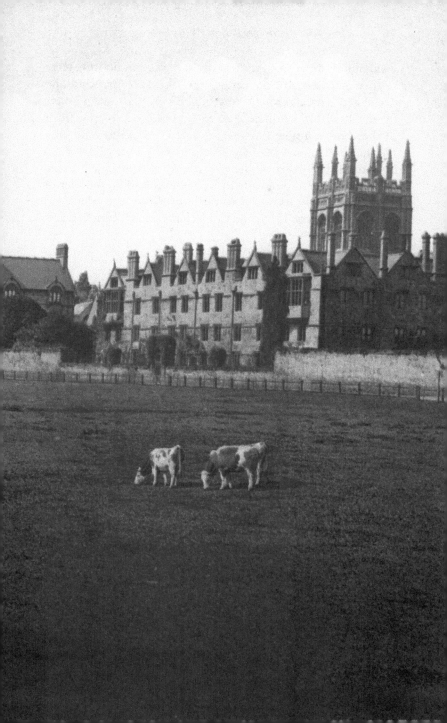

Commoner of the College. The stalls, desks and flooring were restore in 1854; and the ceiling was also reconstructed and decorated with figures of Prophets, Evangelists and Fathers by the Rev. John Pollen, Fellow in 1842–45. In the floor of the choir are nine brasses, the finest being those of John Bloxham, Warden 1337–87, and John Whytton, 1420; and a large full-length effigy of Henry Sever, Warden 1455–71. In the ante-chapel are monuments to Sir Thomas Bodley, founder of the Bodleian Library, 1613; to Anthony Wood, the celebrated Oxford Antiquary, 1695; and to Sir Henry Savile, 26th Warden, 1622.

MANCHESTER COLLEGE

This College is under similar conditions to Mansfield, not being intended for resident students. It was established at Manchester originally in 1786, and after removal to York, returned again in Manchester in 1840, afterwards being transferred to London in 1853; it was finally settled in Oxford in October, 1889, in rooms in the High Street. The Trustees having secured a site in Mansfield Road in 1891, the memorial stone was laid on October 20th, and the College formally opened on October 18th, 1893, for the purpose of instruction in theology, without adopting any particular theological doctrines, such teaching to be open to students who have already graduated.

The main buildings, which comprise three sides of a quadrangle, are in Gothic style, have a frontage to Mansfield Road of three stories, relieved in the centre by an embattled tower; the Senior Common Room being over the gateway, the north wing being the Library, and the Chapel the south wing. On the first floor are the Professors rooms.

THE LIBRARY

This room, 80 feet in length by 30 feet wide, which was the gift of Mr Henry Tate, at the cost of £10,000, is a very handsome room, having large bay windows, one of which is of stained glass, presented by the congregation of Cairo Street Chapel, Warrington. The Library already contains nearly 20,000 volumes.

THE CHAPEL

This is a handsome addition to the beautiful Chapels of the Oxford Colleges. It consists of a nave, and a raised portion fitted with richly carved oak stalls; it has also a handsome oak screen, and on one side a screened chamber containing the organ, which was presented the Mr George Buckton. The windows are specially striking, being all of stained glass from designs of Sir E. Burne-Jones, and were executed by Mr W. Morris.

MANSFIELD COLLEGE

This was transferred to Oxford in 1886, by the Trustees and Council of Spring Hill College, Birmingham, who resolved, with the sanction of the Charity Commissioners, to establish it here as a centre of evangelical work amongst members of the University. The building were erected in 1887–89 at a cost of about £40,000, an occupy a portion of the old Cricket Ground of Merton College, near the University Parks. They are built in accordance with the Gothic style of the fourteenth century, from designs by Mr Basil Champneys, of London, and are arranged so as to form three sides of a quadrangle, with the entrance gateway in the centre of the middle wing, surmounted by a square tower with oriel window; an embattled tower being at its south-east angle.

THE CHAPEL

This forms the eastern wing of the building, and although a plain structure, is very rich in its carved oak wood work, especially in its canopied stalls, and the canopy of the pulpit. It is 84 feet long by 40 feet wide, having six bays with narrow side aisles, and an open roof supported by stone arches, with statues of divines in canopied niches. Two stained glass windows, the gift of Mr and Mrs Haworth, were added in 1890, and an oak screen erected to form an ante-chapel. A fine organ was also added in 1890, presented to the College by Sir W. H. Wills, Bart., M.P. The Chapel service on Sunday mornings (and also at Manchester College) differs from the

ordinary College services in allowing the public to attend, there being seating accommodation for 350 persons. On the exterior or east side of entrance doorway are figures of Origen and Runyan.

The western wing comprises the Library, 76 feet by 33 feet, a well-lighted room, special attention having been given to this in its building, with fine projecting windows and oak roof; it also contains the larger lecture rooms, and the Principal's house with garden attached. The central portion of the buildings includes the dining hall, 41, feet by 20 feet, common room, professors' and other lecture rooms. The lawns are extensive, and have a pretty effect being in raised terraces.

NEW COLLEGE
The title of 'New' has clung to the College for more than 500 years; the original application being that it was 'new' in the sense of the completeness and splendour of its buildings and arrangements, as compared with the earlier colleges of the previous century. The foundation stone was laid with great pomp and ceremony on March 5th, 1380, it being the fifty-fifth birthday of the founder, William of Wykeham. According to the founder's plan, which was carried out solely at his own expense, the College consisted of the principal quadrangle (which include the Chapel, Hall and Library), the Cloisters, the Towers, and the Gardens. The third storey was added to the original building about the end of the sixteenth century. The front quadrangle is 168 feet long by 127 feet wide; the Cloisters, approached by a passage, between the entrance gateway and the chapel, surround an area of 175 feet by 85 feet; they have a ribbed roof of oak, and contain numerous monuments, having been consecrated as a burial place for the College in 1400. The Garden Court was the next building, having been erected in 1682, somewhat after the sty of Versailles, and it is terminated at the entrance to the Gardens by iron palisade and gates, 130 feet length. A third quadrangle was added from 1872 1898, the first portion being from the designs of S Gilbert Scott, and the later portion by Mr Basil

Champneys. The whole is in the Perpendicular style consisting of buildings of four storeys, and having a frontage to Holywell Street of 370 feet, including large tower gateway 80 feet in height, erected as memorial to the late Alfred Robinson, Fellow of the College.

THE HALL

The Hall adjoins the Chapel on the east side. The first important alterations took place in 1504, when the wainscotting and screen, which are in many places most curiously carved, were given by Archbishop Wareham. The old roof of 1386 was taken down about 1790 and replaced by a flat ceiling, which in 1866 gave place to the present magnificent oak roof, the stained glass being placed in the windows also, at a total cost of £6,000. The painting is a valuable one of the Caracci School, and is described in an old authority as 'the Shepherds coming to Christ after his Nativity.' It was presented by a former Earl of Radnor, and was over the altar in the chapel up to 1790. The portraits include the founder, William of Wykeham; Archbishop Chichele, Bishop Ken, Bishop Waynflete, and others.

THE CHAPEL

It is impossible in this brief notice to do justice to the extreme beauty of such a building as New College Chapel; it is only to be realised by personal inspection. Its reredos, which is represented to have originally been of the utmost splendour and magnificence, shared the fate of those of All Souls' and Magdalen Colleges, the visitors of Edward VI having removed the 'images' and ordered the painted windows to be pulled down; 'but,' Anthony Wood says, 'the College not being rich enough, as they pretended, to set up new, promised that they would when they were in a capacity,' so the windows escaped destruction. In 1550, 'the niches, having been filled up with stone and mortar, were then covered with plaster, on whose removal in 1695 some broken statues were discovered, and the whole re-fitted with vairious ornamental work in wood,

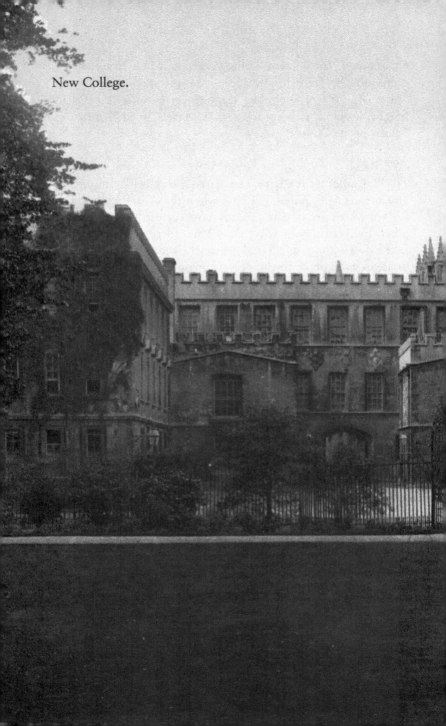

New College.

gilding and painting. In the centre was the Salutation of the Virgin Mary, and over the Communion Table was the Caracci picture. So the Chapel remained until 1788, when the decayed state of the roof causing repairs to be carried out, the old wall at the east end was once more discovered, with some remains of its beautiful niches and work, when the wall was restored under the direction of Mr Wyatt to as near a resemblance of its original appearance as his genius and taste could conjecture.' In 1876 the latest restoration of the Chapel began, under the superintendence of Sir Gilbert Scott. The plaster ceiling was replaced by an oak roof; the panelling and cornice and also the organ-loft were largely replaced with new work; the beautiful sedilia was reconstructed, and the restoration of the reredos completed in 1894, with new grouping of the statues, the plan from the apex of the roof downwards representing a complete illustration of the 'Te Deum.' The restoration on the occasion cost £25,000.

The inner Chapel is 100 feet long by 35 feet wide and 65 feet in height; it is separated from the ante-chapel 80 feet by 36 feet, by a screen supporting magnificent organ, rebuilt by Willis in 1875, with stops and nearly 3,000 pipes. The windows on south side are Flemish, and supposed to be by Rubens' pupils; the figures of saints, those on the north side representing Prophets and Apostles, were placed 1765 and 1774, and are by Peckett of York. The founder's pastoral staff, of costly materials and beautiful workmanship, over 600 years old, is in a glazed 'recess on the left of the Communion Table, is nearly seven feet high, of silver gilt, embellished with Gothic ornaments, and curiously enamelled with jewels, enclosing in the crook of it, the figure of Bishop himself in a kneeling posture. In the ante-chapel is the well-known window of 'The Nativity' by Jervais, designed by Sir Joshua Reynolds. In a space ten feet wide and eighteen feet high, is represented the Nativity of our Lord, a composition of 13 human figures, besides animals. On the left the painter has introduced the portraits of himself and Reynolds as adoring Shepherds. In the seven compartments at the base of window are the well-known

figures by Sir J. Reynolds of Temperance, Fortitude, Faith, Charity, Hope, Justice and Prudence. The original drawings of these when sold in 1821 produced £7,229.

THE GARDENS

Mr Hawthorne, in 'Scarlet Letter' says, speaking of New College Gardens, 'such a sweet, quiet, sacred, stately seclusion, so age long as this has been, cannot exist anywhere else.' The grounds are thickly studded with deciduous trees and evergreens, with magnificent chestnuts and limes of ancient date, intersected with lawn and flower borders. Surrounding the gardens are a portion of the old, medieval City Walls, in excellent condition; the founder entering into an agreement with the City, of whom he purchased the land 'to keep the walls in good repair for ever.'

ORIEL COLLEGE

The proper foundation of this College dates from 1324. In this year Adam de Brome, Almoner to King Edward II, obtained a license, dated April 20th, to purchase a messuage in the town or suburbs of Oxford to found therein to the honour of the Virgin Mary a certain College of Scholars; but in 1325/26 the King enlarged the original plans and became the founder. He (Adam de Brome) being already Rector of the parish of St Mary, secured some property running parallel with High Street, which was already in use by Scholars of the University, and shortly after courteously surrendered it into the King's hands, who having enlarged the original plans, became the founder in 1325/26; fully carrying out the wishes of his Almoner. By Charter dated 1326, the King constituted it 'a perpetual College of Scholars for the study of Divinity and Canon Law and appointed Adam de Brome the first Provost. Amongst the greatest benefactors of the College was Edward III, who, amongst other gifts, in 1328 granted 'the Hospital of St Bartholomew, near Oxford, with all its appurtenances, as a place of retirement for the Society in case of plague.'

The present buildings are comparatively modern, the south and west sides of the Front Quadrangle were rebuilt from

1621–42, and the north and east sides a little later; whilst the second called the Garden Quadrangle, was begun in 1719 and completed in 1817. The Entrance Gateway is opposite the Canterbury Gate of Christ Church, and has an embattled tower showing the Arms of Charles I, and a fine oriel window over the gate. The view from here of the approach to the Hall with its steps and canopied figures is particularly striking.

THE HALL

Built with the Chapel, the Hall was completed in 1642. It is 50 feet long and 20 feet wide, having one of the finest timbered roofs in Oxford. Above the entrance, in canopied niches, are statues of Edward II, Charles I, and the Virgin and Child, which, with its semi-hexagonal porch, makes a handsome entrance. Amongst the portraits are Edward II on his throne, by Hudson; Queen Anne, Sir Walter Raleigh, Thomas Arnold, John Keble, and Cardinal Newman. There are also two valued silver cups which were the gifts of Edward II about 1327, and Bishop Carpenter in 1476; one of which bears the following interesting inscription in Latin:

Drink, gentle Sir, with moderation,
And not from drunken inclination;
Thus health of body is provided,
And strife of tongue may be avoided.

THE CHAPEL

Situated at the south-east corner of quadrangle, this has seen several restorations, the last being in 1884, when a new east window was inserted to the memory of the Provost. The Chapel was completed in 1642, and was built with a transept ante-chapel, the greater part of which was taken into the inner Chapel at the restoration in 1884, by Mr T. G. Jackson; the screen was also thrown back and an organ erected over it. The window, representing the 'Presentation of Christ in the Temple,' dated 1767, which had been at the east end was also removed to the west end, giving place to a very fine

stained glass memorial window, designed by Mr Wooldridge, the subject being 'The Adoration of the Magi.' Stained glass windows were also added on the north and south sides of the Chapel. There are two marble monuments to the memory of Dr Edmonds, D.C.L., 1746, and Dr Carter, Provost 1708–27, the latter by Westmacott, executed in 1871.

Amongst the noted men of the last century who have made Oriel famous are Pusey (who went from Oriel to his Professorship at Christ Church), Keble(elected Fellow in 1811 at the age of 18), Cardinal Newman, Whately, Archbishop of Dublin; Hughes, author of *Tom Brown's Schooldays;* Mr Goschen, the present First Lord of the Admiralty; and the late Mr Cecil Rhodes; whilst Sir Walter Raleigh was among earlier students.

PEMBROKE COLLEGE

The history of this College is of special interest, it is in its foundation purely local. It was founded 1624 by the Corporation of Abingdon from the endowments of Thomas Tesdale, of Glympton, and Richa Wightwick, Rector of Ilsley. Mr Tesdale (who was the first boy placed in Abingdon School by its founder in 1563) being anxious to provide the boys of the school with University education, left a sum of £5,000 for the purpose of endowing fellowships or scholarships at any College in Oxford. Before an agreement was completed between Balliol College and the Corporation of Abingdon (the trustees), they having the promise of the charity of Mr Richard Wightwick, who also intended to found scholarships at Oxford, determined to found a new College in the old society at Broadgate Hall, which had partly belonged to the Abbey of Abingdon. They accordingly obtained letters patent from the King, James I, ordaining Broadgat's Hall should be named Pembroke College, after the Chancellor of the University, the Earl of Pembroke. Four of the scholars are still elected from Abingdon School. The buildings, nearly all of which are modern, are Gothic in character.

The front, rebuilt in 1830, is of two portions, each of three stories, with a battlemented parapet at right angles to each

other; in the angle on the north front is a gateway tower of four stages, with an oriel above the entrance and embattled parapet rich with panelling; the front facing the east being the Master's lodgings. The buildings form two quadrangles, the Library being on the right of the entrance gateway. On the north side of the second quadrangle a range of new buildings was erected in 1846 about 150 feet in length, making the quadrangle complete; and thereby transforming it into one of the prettiest and most attractive quadrangles in Oxford.

THE HALL AND LIBRARY

The Hall, erected in 1848, is a fine building of five bays with an embattled tower and an elegant louvre in the centre of the roof. At the upper end of the south side is a tall oriel with three tiers of lights, reaching almost to the roof. The walls are hung with a large number of portraits, including the founders, Charles I, Queen Anne, Simon, Earl of Harcourt; several Bishops and others. The present Library is the old Refectory of Broadgate's Hall, and contains, amongst other treasures, a bust (by Bacon) of Dr Johnson, a member of this College, whose rooms were over the gateway on the second floor.

THE CHAPEL

Situated on the south side of the second quadrangle, this was built 1728–32, it being a small structure of Ionic character, having pilasters between the windows and a panelled parapet; its south side being upon the Old City Wall. In 1829 the Chapel was modernised, ar has later been beautified, its decoration having been completed by Mr C. E. Kemp in 1885. The windows were filled with admirable stained glass at the same time, but the series were completed in 1893 by the erection of two memorial windows to the late Dr Evans, Master 1864–91. It has also a fine reredos of veined marble enclosing a painting by Cranke, of Rubens' 'Christ after his Resurrection.' The ceiling is a good example of decorative work.

QUEENS COLLEGE

The front of this College, occupying 140 feet frontage to High Street, with its bold cupola, is one of the more striking features of the many beauties of 'the High.' The first buildings occupied by the Society are described as 'Temple Hall and other buildings near St Peter's Church. On this foundation in the year 1340 Robert Eglesfield, chaplain and confessor to Philippa, Queen of Edward III, founded the College, with its front opposite St Edmund's Hall. In 1349 the King granted a patent for building the chapel, which remained in use until 1713, in which year the new chapel was begun. In 1710 the front quadrangle was commenced, which was completed principally through the benefactions of John Michel, of Richmond, member of the College. In 1778 an alarming fire destroyed, in a few hours, the whole of the western wing of the new quadrangle, which was rebuilt at a cost of over £6,000, contributed by members of the College and their friends, including the sum of,£1,000 given by Queen Charlotte.

THE CHAPEL

The windows removed from the old chapel were painted by Van Linge in 1636, and being repaired by Price in 1715, are still in a good state of preservation. The two windows on the south side of the chancel represent 'The Ascent from the Sepulchre' and 'The Ascension.' In those on the north side 'The Resurrection of the Dead' and 'The Last Judgment.' In the windows on the south side of the chapel are 'The Adoration of the Magi' and 'The Descent of the Holy-Ghost,' the other two being figures of a bishop, popes and saints. On the north side are 'The Last Supper' and 'The Salutation,' with early fathers. The ceiling, of excellent stucco, is decorated with a painting of 'The Ascension,' by Sir James Thornhill, and in the middle window is 'The Holy Family,' by Price; beneath which is a copy of Correggio's 'Night,' in the Dresden Gallery. This building, of 100 feet in length, with its Corinthian columns, valuable windows, and line decoration, is one of the best examples of restoration in the University.

THE HALL

This was built in or about the same year in which Provost Lancaster laid the foundation stone of the first quadrangle (1710), the design of which is supposed to have been Sir Christopher Wren's. The room is a noble one in proportion and effect, and is embellished with portraits and arms of founders and benefactors, while in the gallery adjoining are similar portraits. An old custom still exists in this College, dating from the days of the founder, of summoning the members to dinner by blowing a trumpet, the usual course being the ringing of a bell. In this Hall also is still carried on that well-known ceremony of the 'Boar's Head' procession accompanied by the singing of a carol. The traditional origin of the custom is that a wood at no great distance from the College was at one time infested by a wild boar, which was a terror to all the neighbourhood. One day a student of the College studying Aristotle in the wood, suddenly perceived the animal approaching him. The scholar waited for him and as he was going to attack him thrust the Aristotle down his throat and choked him. How early this originated does not appear, but a version of the carol printed in 1521 is in existence.

THE LIBRARY

Built 1692-4, this is a large and noble apartment, described as 'one of the most splendid in the University.' The western elevation, towards the Fellows' Garden, has an elegant appearance, the basement being decorated with eight statues in niches, on the right being King Edward III and Queen Philippa, King Charles I and his Queen, and on the left Robert Eglesfield, Bishop Barlow, Archbishop Lamplugh, and Sir Joseph Williamson. The interior has some excellent carvings of Grinling Gibbons, and a fine stuccoed ceiling by Roberts. In the north window are original portraits on painted plass of Henry V and Cardinal Beaufort. The Library contains about 70,000 volumes, and a fine collection of Egyptian, Grecian, Roman, and other antiquities.

Amongst many distinguished men who were educated at this College were the eldest son of Edward III. (the Black Prince) and Henry V.

ST JOHNS COLLEGE

This College was originally a house of Bernardine Monks (a branch of the Cistercian Order), and was purchased by Archbishop Chichele in 1436, and converted into St Bernard's College. The improvements to its buildings, however, had scarcely been completed, when in 1539 it was suppressed, the King giving it to his new College of Christ Church. The Hall had been built in 1502, and the Chapel completed in 1530. Four years later, Sir Thomas White secured it from Christ Church, and on the first day of May, 1555, under a grant from the Chapter of Christ Church, St John's College was founded 'for Divinity, Philosophy, and the Arts, to the Praise and Honour of God, the Virgin Mary, and St John the Baptist.' At the time Sir Thomas White took possession it is recorded that for nearly twenty years the buildings had remained uninhabited, but were easily repaired. Though they have since undergone many alterations they remain structurally the same after the lapse of nearly 500 years. Varied fortunes attended the new College, for after the death of the founder in 1566, St John's, which had become a 'hot-bed of Catholicism,' languished terribly. In the next century, however, owing to Laud's great munificence, and the loyalty of the College to Charles I, 'was second to none in the University in position an influence.' The inner quadrangle is sometimes called 'Laud's Quad,' it being built by him during his Presidency of the College, under the designs of Inigo Jones, together with part of the picturesque garden front. Over the main entrance in St Giles is an old statue of St Bernard, whilst in the inner quadrangle over the colonnades, are two bronze statues of King Charles I and Queen Henrietta, said to be by Fanell a Florentine artist. The statues were presented by Laud.

St John's College. (Courtesy of LOC)

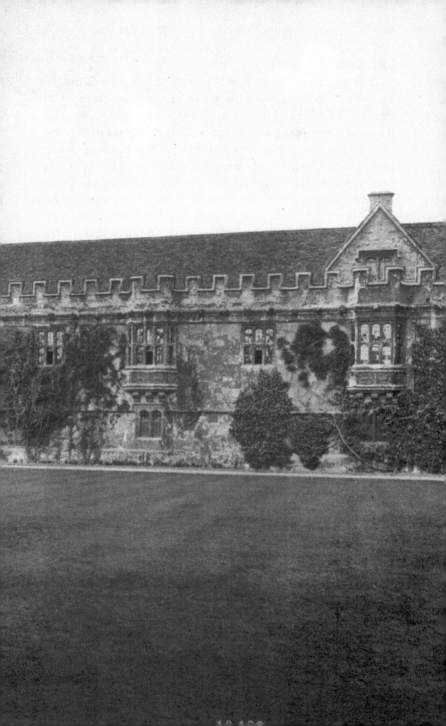

THE CHAPEL

This is situated on the north side of the first quadrangle, and the structure remains as in use in the time of St Bernard's College. Alteration and redecoration took place in the century just passed, and amongst objects of interest are the figures in the east window of Sir Thomas White and Archbishop Laud, who lie side by side under the communion table. It also has an urn containing the heart of Dr Rawlinson, who was buried in St Giles' Churchyard. There is a beautiful small Mortuary Chapel attached, now used as a vestry, built by Dr Baylie in 1662, to receive the remains of his son; its groined fan-tracery ceiling is one of the finest features of the building. Some fine wood-carving is in the organ gallery, and the altar-piece is of rather striking character, being painted stone figures representing the Baptism of Christ, the water being poured from shell, with two angels in attendance. The interior was redecorated, and three memorial windows inserted 1872, showing the figures of Apostles and Prophets, with scenes from their lives. The window over the communion table is very rich in its colouring, ten subjects being beautifully rendered. The central scenes are the Crucifixion and the Nativity, the Visitation and the Annunciation, with figures of St John the Baptist, Virgin Mary, St John Evangelist, St Bernard, Sir Thomas White, and Archbishop Laud.

THE HALL

The old Refectory of St Bernard's has a fine arched roof, with a screen of Portland stone. It was built in 1502, but has undergone considerable alteration since that date. Amongst its portraits are those of the Founder, Archbishops Laud and Juxon, Thomas Rowney, M.P. for Oxford, 1695, King George III in coronation robes, Sir Walter Raleigh, King Charles I and Queen Henrietta. Beneath some portion of the old buildings on this north side is a splendidly preserved crypt, now used as store rooms. It has an exceedingly flat roof, originally supported by a single column; an old fireplace is still existing

in these vaults, which very greatly resembles in its style of building the old Roman chimneys of flat tiles.

THE LIBRARY

This consists of two large rooms on the south and east sides of 'Laud's' Quadrangle. It now contains not only a very large collection of books, many of which are rare copies, but it is very rich in relics and curios. At the completion of the new buildings in 1636, Laud entertained Charles I and the royal party in this room.

'The King, the Queen, and Prince Elector dined at a table which stood across at the upper end, and Prince Rupert, with all the lords and ladies present, which were very many, dined at a long table in the same room,' and later on George Wilde's play of 'Love Hospital' was performed by members of the College. Passing from this quadrangle through a passage with curious old doors and a fan-traceried roof we enter the garden.

THE GARDENS

It is often questioned which are the most beautiful of the College gardens; but for quiet retirement and peaceful repose in the midst of sylvan scenery, nothing can excel the Gardens of St John's. They occupy an area of about five acres, with wide lawns, well planted shrubberies, and finely grown cedar and chestnut trees. They were first laid out in the year 1612 by one of the Fellows of the College.

TRINITY COLLEGE

The foundation of this College begins a new era of University life, it being the first of the Colleges founded after the Dissolution of the Monasteries. Amongst the hardships of the Dissolution no case seems more arbitrary than the suppression of Durham College, which stood on this site, as one half of its number were lay students; but as the other half were Benedictine Monks it was condemned. The site and building however, were reserved from the general destruction by Dr

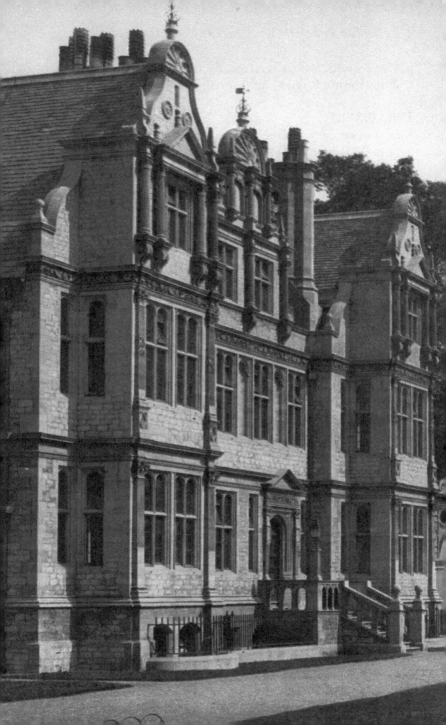

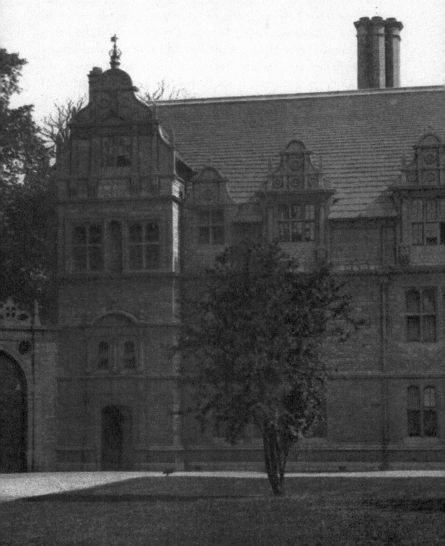

Trinity College.

Wright, who had occupied them for some yet as Principal of Durham Hall. Going back to the foundation of this Hall we find the first grant of an inclosure of land in Oxford made 'to God and our Lady ... and to the Prior and Convent of Durham' is dated about 1286. It is conveyed by Mabelle Wafre, Abbess of Godstow, and consists of nearly the same ground that is now occupied by Trinity College. At the suppression the site came into the possession of George Owen, physician to Henry VIII, from whom Sir Thomas Pope bought it, he being Privy-Councillor to the King; and in 1555 he founded Trinity College, dedicating it to the 'Holy and Undivided Trinity.'

The College is entered from Broad Street through gates of ironwork, adorned with the arms of the founder, the Earl of Guildford and the College, and one cannot but be struck with the beauty of this quadrangle, enhanced by the new buildings completed in 1887, and the new house of the President. Passing under the square tower we enter the first court, in which is the chapel.

THE CHAPEL

Completed in 1694, at the cost of Dr Bathurst, President of the College. This is said to be one of the most favourable specimens of the Corinthian style in England; the gateway and tower, which are separate, being Ionic. The carving of the interior, by Grinling Gibbons, particularly of the cedar screen and an altar-piece, is unrivalled. The ceiling was painted by Berchet, a French painter, its subject being 'The Ascension.' The monument of the founder and his second wife, with effigies at full length, in marble, is placed at the upper end of the chapel. The stained glass windows were added in recent years, containing figures of saints and early fathers. A very fine copy of Andrea Sarto's 'Deposition of Florence,' painted by Cannicci, faces the entrance door, over which is a memorial window to Isaac Williams, with richly coloured glass, the subject being 'The Crucifixion.'

THE LIBRARY

The most ancient part of the College, being the same which belonged to Durham College. It was found by Bishop Bury, who died in 1343. In 1765 after many previous attempts to repair the ruined windows, they were taken down, renovated, and replaced, but they still exhibit many curious remains of old painted glass, particularly noticeable being the figures of the four Evangelists, Edward III and his Queen Philippa, and St Thomas-a-Becket, who is represented with a fragment of the dagger of Fitz-Urse in his forehead.

THE HALL

Built in the Gothic style in the year 1618. Later, in 1772, improvements were made, consisting of new ceiling, wainscotting, and chimney-piece. The statue of the founder (Sir Thomas Pope) is over the entrance and portraits of benefactors decorate the walls.

The West Court or Quadrangle was designed by Christopher Wren, and was completed in 1682. From this quadrangle is the approach to the gardens.

THE GARDENS AND LIME WALK

These Gardens, with their broad grass plots and splendid trees, one is never tired of visiting. The principal feature of beauty is perhaps the old Lime Tree Walk, which, with its cleverly-trained twenty-four trees on each side, not only affords a most enjoyable parade, but is in itself a veritable bower of beauty.

UNIVERSITY COLLEGE

Great difference of opinion exists as to whether this College should not be considered as the first College founded in Oxford. This point we will leave for the three Colleges which claim that honour to settle between themselves – those three being University, Merton and Balliol. The foundation of the College is said to have originated with William of Durham, who is supposed to have been educated at Oxford, and who died in 1249. By his will he bequeathed to the University

the sum of 300 marks for the purchase of rents to provide a maintenance for a considerable number of advanced students. As early as 1253 the trustees made the first purchase, and in 1270 other properties having been brought together producing an income of 18 marks, the trustees selected four masters or scholars to live together in one house, and a body of statutes was agreed upon in 1280. It is supposed they removed to Great University Hall, their present situation in High Street, about 1343. At the beginning of the reign of Henry VI, the old buildings which stood without any uniformity, having been erected at different periods, and consisting of several halls or tenements, were pulled down, and buildings erected in the style of a quadrangle. The foundation was laid in 1634 on the west side, which was built in two years, this being followed by the High Street frontage, the Hall and Chapel being a few years later, in 1639. Owing to the troublous times at Oxford in connection with Civil War the east side of the quadrangle was not completed till 1674. The buildings have a frontage High Street of 260 feet, with two gateways having flights of steps, and battlemented towers.

Over the principal entrance to High Street is a statue of Queen Anne, and on the interior is the statue James II; the second gateway has over it on the one side that of Mary, daughter of James II, and over inside that of Dr Radcliffe, who built the second quadrangle at his own expense in 1719. The principal quadrangle is 100 feet square, having on its south side the Chapel and Hall, and an additional structure approached by a small cloister on the right, contains a memorial statue to Shelley the poet, the gift of Lady Shelley to the College in 1892.

THE HALL AND LIBRARY

The Hall was commenced in 1640; but it was not completed until the reign of Charles II. The interior was refitted in the year 1766 at a cost of about £12,000 the elegant chimney-piece being contributed by Roger Newdigate, D.C.L., for many years M.P. for the University. The new Library was

built in 1861 from designs by Sir Gilbert Scott, R.A., and is Decorated style. It contains fine statues of Lord Edon and Lord Stowell, both former members of the Colle and also a very rare (imperfect) copy of the Hereford Missal, of which there are only four copies known exist, printed in 1502.

THE CHAPEL

Completed in 1665, the chapel was restored at great expense in 1862. There are fine specimens of wood carving by Grinling Gibbons, the old cedar wainscotting and oak screen having been preserved at the restoration. The seven windows, north and south, are good examples of Van Linge's of 1641, and are said to be amongst the best of their kind in Oxford. It is worth recording that an old authority says in reference to these windows, 'It fortunately happened that the building was not at that time (1641) in a state to receive them; so that they escaped the destruction to which works of art of that description were devoted by the anti-ecclesiastical spirit of the period.' The subjects of the enamel paintings on the south side are the 'Fall of Man,' 'Abraham entertains the Angels,' 'The Offering of Isaac,' 'Martha and Mary,' and 'The Expulsion from the Temple' with, on the north side, 'Jacob's Dream,' 'Translation of Elijah,' and 'Jonah and the Whale.'

WADHAM COLLEGE

The early history of the site of this College is that it was occupied by extensive buildings belonging to Augustinian Friars, who came to England in the middle of the thirteenth century. They here taught theology and philosophy, and became so famous that for nearly three centuries after their dissolution the practice of holding disputations, called 'doing Austins,' continued without interruption, and was only abolished in the year 1800. No traces of the buildings now exist, except in external walls; the last portion, pulled down early in the nineteenth century, being an old building just above the King's Arms Hotel, the site being now occupied by twelve sets of rooms added to the College. The foundation

of the College was intended by Nicholas Wadham, who set apart a considerable sum of money for the purpose, but his death in 1609 prevented carrying out his intentions. His widow, howeverm being his executrix, carried out his views the follow year, purchasing the site and the remaining ruins for the citizens of Oxford for £600. The foundation was laid in 1610, with great ceremony, 'the Vice-Chancellor, doctors, proctors, and others, accompanied the Mayor and his brethren, walking in process from St Mary's Church with Te Deum, chanted choristers and singing men, and the whole conclu with an oration and an anthem.' The buildings who completed in 1613 at the cost of £11,360, and first Warden, Dr Wright, admitted in that year.

THE HALL

The hall was built with the College buildings, but its decorations not completed until 1622, that year being recorded on some of the old glass. Over the entrance, facing the quadrangle, is a statue of James I under a canopy, with the two figures of Nicholas and Dorothy Wadham, the former in armour, holding in his right hand the model of the College. Dr Turney, whilst Warden, considerably improved and embellished the Hall, and gave splendid glass in the great south window'. The large oriel and the side windows are adorned with the arms of the chief members of the College. This Hall is now said to be one of the most handsome and appropriate specimens of College Refectories to be found in either University. It is 82 feet long, 35 feet wide, by 37 feet high, and it contains amongst a large number of portraits, Nicholas Wadham the founder, and also the wife, King George I, King William III, and Admiral Blake.

THE CHAPEL

Although the general characteristics of the architecture of the College is its uniformity, in the chapel, hall, and library windows are clearly to be noticed distinct differences, indicative of the Transitional period of architecture. It has been suggested by some that the original windows of the

Augustinian Chapel were incorporated into the new building, which might account for some of these differences of style, but this must be left to conjecture. It is 83 feet by 35 feet and 37 feet high, and is one of the finest in Oxford; the open-timbered roof being a curious example of adapting Gothic to Jacobean detail, whilst the workmanship of the whole is beautifully finished. The ancient glass by Van Linge has been preserved, and amongst the papers of the College is an interesting one illustrative of the contracts with glass Stainers; being the contract signed by Bernard Van Linge in 1621 for the east window at £100. The four windows on either side are also of stained glass. In the east window the subjects are divided into two compartments, being the principal types in the Old Testament relating to our Saviour, and in the ten compartments below, the most remarkable circumstances of His history recorded in the New Testament. There are also the arms of the founder and other benefactors. The other windows on each side are of our Saviour, the Prophets and Apostles, of the date 1838. The ante-chapel floor was paved with marble in 1678, and the handsome brass lectern presented in 1691.

THE LIBRARY AND GARDENS

The library is built over the kitchen beyond the quadrangle, and forms an additional wing, corresponding with the Chapel on the opposite side, and conneced with it by a cloister. It is 55 feet by 30 feet, and the end is lighted by a handsome window, the windows being narrow and of Gothic character. Gardens, entered by a passage near the clock, possess some very fine trees, including noble cedars, auricar and others, and are nicely laid out.

WORCESTER COLLEGE

This College is described as being the last of the Colleges, it being established as the present foundation in 1714 by the Trustees of Sir Thomas Cookes, Bentley-Pounceford, Worcestershire. The early history of its previous foundations

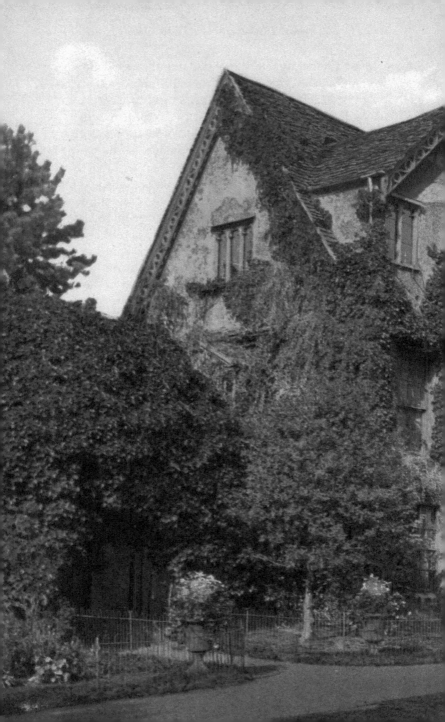

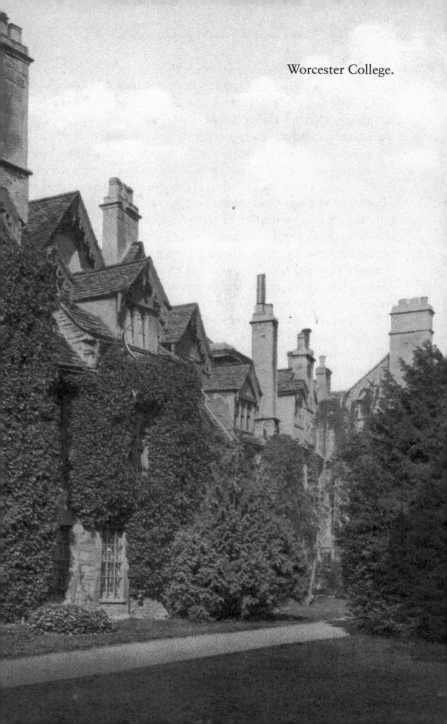

Worcester College.

is a chequered but extremely interesting one. The original foundation is dated 1283, and was established by Baron Giffard Benedictine Monks from Gloucester, and called Gloucester College. Other Benedictine houses soon obtained leave to associate themselves with the foundation, including the religious houses of St Albans, Abingdon, and Norwich; the members of each house, which were distinguished by escutcheons and rebuses above the doors, constructing separate dwellings their students. On the south side of the quadrangle are examples of these the original buildings, rebuilt in the fifteenth century. At the time of the suppression of the monasteries it was in a flourishing condition, but shared the usual fate, and was taken over by the Crown. After a few years, in which the buildings were used as a palace for the Bishop of Oxford, they were sold about 1563 to Sir Thomas White, the recent founder of St John's College, and the name was changed to St John Baptist Hall. Success followed the change for a few years, but later the Civil War so seriously affected it that Anthony Wood says, about the year 1680, 'there was not one scholar in Gloucester Hall, only the Principal and his family, and two or three more families that live there in some part to keep it from ruin; the paths are grown over with grass, and the way into the Hall and Chapel made up with boards.' Towards the close of the century, Dr Woodroffe appropriated the College to the education of Greek students; in the meanwhile Sir Thomas Cookes having expressed a wish to endow a College at Oxford, set apart by his will £10,000 for this purpose, and having died in 1704, his trustees in 1714 purchased St John Baptist Hall and founded Worcester College.

THE CHAPEL AND HALL

The Chapel, though small, is one of the most elaborately decorated in the University. In 1870 its restoration was completed, at a cost of £5,000, and is now said to be one of the finest examples of Renaissance decoration in England. The wall decoration illustrates the Te Deum and Benedicite; the altar-

piece shows 'The Entombment of Christ'; the chancel floor exhibits in mosaics 'The Parable of the Sower' whilst a very rich ceiling has two illustrations of 'The Fall of Man,' in niches, in the angles of the Chapel are statues of the four Evangelists. The Hall, corresponding exactly in size and character with the Chapel is a fine handsome room, ornamented with fine Corinthian columns at the west end. It is enriched by a fine dado of coloured wood, and by a handsome marble fireplace. It has a fine old Flemish painting Snyders, representing a Dutch Fish Market; over fireplace is a full-length portrait of Sir Thomas Cool the Founder, and in other parts of the Hall are portrait of Dr Blechynden, the first Provost, Lady Holford and others.

The Library, constructed over an open arcade piazza, extends to 100 feet, and has a gallery of same length. It is stored with rare and curious wo amongst others being the original designs Whitehall.

THE GARDENS AND LAKE

The most attractive feature of Worcester College both from the citizens' and visitors' point of view, the lovely secluded gardens with the extensive lake which, by the kind courtesy of the College Authority are at all times thrown open to the public. This agreeable spot was first selected by the White Friars, Carmelites, on their arrival at Oxford, they having in 1254 obtained a grant of land from the Constable of the Castle, one Nicholas de Meules, to which, having afterwards made addition, 'they began,' Wood says, 'to covet fine gardens and pleasant walks, adorned with water, groves, etc.'

ST EDMUND HALL

The records of Magdalen College, under the date of 1260, in referring to this Hall, state that Ralph gave it to his four sons, the building receiving the name of 'the Hall of the Four Sons of Edmund.' Ralph Edmund was a citizen of Oxford in the reign of Henry III, which gives 1233 as the date of the foundation. It is also said to take its name from Edmund Rich, of Abingdon,

Archbishop of Canterbury, who lectured in schools on this site as early as 1219, and who after his death was canonised. In 1269 it was purchased by the Canons of Osney for the purposes of education, but the record of its history is lost until 1317, when John de Cornubia was Principal. It was suppressed by Henry VIII, and granted to two citizens of Oxford, who sold it to the Provost of Queen's College, and in 1557 he devised it to his College, which, having been confirmed by Congregation and the Chancellor of the University, secured to them the perpetual right of nominating the Principal. The irregular and quaint buildings, chiefly dating from the middle of the seventeenth century, occupy little more than three sides of a quadrangle; the Hall forming the west side, and the Chapel and Library being on the east side. This Hall is the only example left of the old system of University life ante-dating the first College foundation.

The Chapel and Library are interesting as being the only case in which they are comprised in one building. The building dates from 1680, and is of singular character, built in the Classic style; the entrance flanked by two Corinthian columns rising through both storeys, and supporting a pediment. The Chapel memorial windows of recent date, and a stained glass east window, designed by William Morris. The altar piece represents 'Christ bearing His Cross.' The upper storey is the Library, which contains several thousand volumes of classical and theological works many of which are rare.

THE CATHEDRAL

This building is frequently erroneously termed 'Christ Church Cathedral,' the proper the being 'the Cathedral Church of Christ.' A church it had an existence several centuries before became the Cathedral of the Diocese of Oxford, transference of the bishopric from Osney Abbey, Oxford Cathedral taking place in 1546. It was originally the Church of the Priory of St Frideswide and is directly connected with the earliest recorded history of Oxford, carrying us back to Saxon days. Although much of the earliest history is legendary, story of its original

foundation is generally accepted as founded on fact, and quoting from Anthony Wood may be thus summarised: 'About the year 727 there lived at Oxford a petty king named Didan, who built a house or founded a nunnery for his daughter, Frideswide, which foundation consisted of two religious virgins of noble birth; as, his daughter "being a princess, she utterly disliked the notion that sshould be subject to her inferiors." After taking the veil in her own nunnery, she was sought in marriage, "being accounted the flower of all these parts," by Algar, King of Leicester, who would not take a refusal, but sent ambassadors, who were smitten with blindness in endeavouring treacherously to carry her off. He then made for Oxford, and finding she had taken refuge amongst the woods at Bampton pursued her and was smitten with blindness also.' When she returned three years later, the historian continues, 'the citizens lived, if I might say, in a golden age, for no king or enemy durst approach Oxford.' St Frideswide died in 739, and was buried in her own church. The main facts of the above story are given in a document of St Frideswide's Monastery of 1004; in which King Ethelred grants a Charter to them. The oldest part of the present building is a piece of wall at the eastern end, which is probably part of the original church built in the first half of the Eighth Century. The Priory afterwards became a Monastery; after which the Augustinian Canons replaced the Monks, about 1122, under Guimond, a reputed Chaplain of Henry I; and the relics of St Frideswide, having become renowned for the working of miracles, increased its glory so much that its wealth and importance were largely augmented, until in 1524 Wolsey obtained the surrender of it to the King by John Burton, the Prior, for the building of his College; its revenues amounting to £300 a year. By the document of 1004, above quoted, we find that in 1002 the church was burned, under the following circumstances: Ethelred early in 1002 bought off the Danes by the enormous payment of £20,000, and granted leave for some of them to settle in Wessex; after which in November of the same year he gave orders that on St Brice's Day all the Danes in his dominions should be put to death; and in the Charter he

acknowledges giving the order and carrying out the same. The Charter states: 'But as many the of Danes who dwelt in the City broke the doors and bolts and entered the sanctuary of Christ by force striving to avoid death, the people followed them, and failing to turn them out, flung fire upon the timber work, and burned the church with its ornaments a books.' It is said that at this early date there was a tower in which the last stand of the Danes was made. In 1009 the Danes revenged themselves by unexpected advance through the forests of the Chiltern Hills and sacked and burned Oxford. There is much difference of opinion as to whether Ethelred rebuilt the Church or that it perished, and that in the latter half of the twelfth century, it was rebuilt or restored. The Chapter House doorway, however, seems today to show work earlier than the end of the twelfth century. The upper portion of the Tower, with the addition of its spire, was built at the beginning of the thirteenth century, together with St Frideswide's Chapel; whilst in the fourteenth century the Latin Chapel was added. The glass in the windows on the north side are fourteenth century work, whilst the east window commemorates the story of St Frideswide, from design by Sir E. Burne-Jones. During Wolsey's operation in the building of his Cardinal's College he swept away the three west bays of the nave, seriously reducing the dimensions of the church, and to him is also attributed the rich vaulting of the roof of the choir. Ingram, in his 'Memorials,' mentions that some say the Cathedral thus mutilated remained in the condition Cardinal Wolsey left it until about 1630; but other writers affirm that large repairs and alterations were made at the time of the removal of the bishopric from Osney to Oxford in 1545. 'In 1630,' so says Anthony Wood, 'the Dean and Canons took down all the old stalls in the choir, and in their places put up those that now are,' and at the same time in laying down the new pavement of the choir and side aisles they removed the old memorial tablets, some of which are said to have had at that date Saxon inscriptions, and which have been unfortunately altogether lost sight of. There seems to be some reason for thinking these memorial slabs were used for covering up a drain which was

made across 'Tom Quad' at the time of these alterations; and it is not too much to hope that if there is any foundation for the statement, that steps should be taken to recover these valuable mementoes before all trace of them is lost for ever.

Upon entering the Cathedral, one cannot help being struck with the great contrast between the plain but substantial work of the early portion of the building, and the richness of the early sixteenth century roof of the choir. An extraordinary feature which cannot fail to attract attention is that the Norman pillars are carried up through the triforium on the inside, with half capitals fixed at different heights. The building consists of a choir of five bays with aisles, and on the north side two chapels of four bays, and on the south one chapel; a central tower and spire, nave of four bays with aisles, a large vaulted western entrance, north transept with western aisles of three bays, and south transept communicating with the cloisters. Th eastern end of the choir has been recently rebuilt as far as possible in accordance with the original work and has two recessed Norman windows surmounted by a wheel window, all of stained glass, executed by Sir Gilbert Scott in 1871. A fine reredos in sandstone richly gilded, has since been added. The Bishop's Throne on the south side is of walnut, and was erected as a memorial to Bishop Wilberforce, late of Oxford at a cost of £1,000. On the north side of the choir is the lady chapel, dating from the middle of the thirteenth century; on its north side are interesting tombs, the first at the west end having the figure of an armed knight, Sir G. Bowers, 1425; the second, under a canopy of Early Decorated work, is a fully vested Prior, supposed to be Alexander Sutton, Prior of St Frideswide, 1294; there is also the altar tomb with effigy of Elizabeth Montacute, *d.* 1354. The east window of this chapel is a memorial to Frederick Vyner, of Christ Church, murdered by a Greek brigand in 1870; near which is St Cecilia's window, presented in 1873 by Dr Corfe, organist of the Cathedral. The Latin Chapel adjoining was completed in 1359, and has some of the woodwork of the old Priory Church. The wooden watching-chamber was erected in the fifteenth century, from

which a 'watch' was kept on the riches of the shrine, by the monk whose duty it was to guard the treasures. The large window in the north transept, by Clayton and Bell, was presented by the Marquis of Lothian in 1876, as a memorial to his brother; the subject being St Michael expelling the Dragon and Fallen Angels. The window at the west end of the north aisle is one of several that existed early in the seventeenth century of Van Tinge's, representing the story of Jonah and the Gourd, the others having given place to memorial windows. In St Lucy's Chapel, south of the choir, is the curious Becket window of the year 1350, representing the murder of the Archbishop, the head of Becket having been obliterated, it is said, by command of Henry VIII. At the eastern corner of the chapel is the altar tomb, under recessed canopy, of Robert King, last Abbot of Osney and first Bishop of Oxford, *d.* 1557; the window above showing the Bishop in his canonicals, with the Abbey in the background; this window was preserved by its removal by a member of the family before the surrender of Oxford in 1646, and was replaced after the Restoration in 1661. Among the many memorials are a life-like bust in marble of Prince Leopold in the South Chapel; monuments with effigies to Dean Godwin, 1590, and Robert Burton, B.D., author of the Anatomy of Melancholy, 1640, in the lady chapel. A brass in the floor shows the supposed resting-place of St Frideswide, whilst a marble slab in the nave marks the burying place of Dr Pusey. The organ screen is remarkable for its curious mixture of Gothic and Italian detail. The organ, which was built by Schmidt in 1680, and since improved by Gray and Davison in 1848, was placed in its present position in 1876, the framework of the organ loft being completed in 1888. Adjoining the south transept is the entrance to the cloisters, from which the chapter house is entered by a fine Norman doorway, of the supposed date of 1180; the interior of the building is an excellent restoration of Early English architecture. In the south wall is fixed the foundation stone of Wolsey's College Ipswich, bearing the date 1528.

OLD STUDENT LIFE

The features of University Student Life in the Middle Ages, when Oxford was crowded with young men and boys desirious of availing the selves of educational facilities, and the features of the present day life at Oxford are so vastly different that it is almost impossible for the mind to realise such difference could exist. It is difficult to form any correct opinion as to the numbers, as statements vary considerably. Florence of Worcester (writing of the time in which he was living) referring to the exodus scholars from Oxford in the year 1209, incidentally mentions 'that all masters and scholars seceded from the University to the number of 3,000 leaving not one behind.' The Bishop of Armagh, in 1357, stated that in his University days, in 1320, they numbered 30,000 although he admitted there were only 6,000 in that year. Accepting this latter number as a correct estimate, in view of the knowledge that the population of Oxford must have been exceedingly small in the days, the population at the Survey in 1085, being between 1,000 and 1,500 only; we are lost in the consideration how the number of 6,000 – rougly speaking, double the number of present day students could have been provided for at all. It is described as being a seething mass of young life, full of disturbing elements; in which anything was good enough to form a division and produce constant brawling and fighting, the favourite cry being 'North against South'; the contentions between these parties sometimes attaining the magnitude of a battle. In 1252 one of the most serious of these inter-student conflicts took place, resulting in such restrictive measures being passed that abolished the celebration of all national festivals, and the imposition of an oath on all members of the University not to break the peace in this way. It is known that the students were in such large numbers that they were crowded in little 'Halls,' or in the houses of private citizens. The 'Halls' were houses rented by a group of students, who selected one of their number to act as principal, look after the commissariat, and exercise headship over his fellow-lodgers. In the days of Edward I there are said to have been 300 of such

'Halls' in Oxford. As Falkner in his 'History' states the life of the students in such places was rough beyond description; whilst their lodgings were squalid and over-crowded, and their habits such as to offend all modern ideas of comfort, sanitation, or decency.

PRESENT STUDENT LIFE

No contrast could be greater than that afforded by the surroundings and daily life of the Oxford student of today as compared with the student of the thirteenth and fourteenth enturies. Whilst the old student was encircled with a loop-holed city wall, and the streets intersected by a labyrinth of squalid lanes, crowded with hostelries, the present student enjoys the fullest advantages which sanitary science can produce in wide streets lighted with electricity, every house inhabited by students being required to pass an official sanitary inspection, and nearly every College having its own large private gardens and cricket and tennis grounds. The whole features of College life have also undergone an entire change, today's students being drawn from an entirely different class; the former being largely those who combined education with, if not labour, at least the strictest economy in their studies; whilst the student of today is almost without exception of the wealthy or middle class, to whom economy is a secondary consideration. The hours devoted to study also have since those early days of highly-valued educational facilities been considerably reduced, the present day requirements being lectures generally from 10 to 1, students sometimes attending two of an hour each, but more often only one, and often absenting himself altogether. The afternoons, up to dinner at six in winter, and seven in summer, are almost without exception devoted to football, athletics, cricket, boating or other pleasures, leaving the hours after dinner free for study; which to the earnest worker are very valuable, when he is able to 'sport his oak,' a sign even to his friends that he is to be undisturbed. The wild scenes of turmoil and bloodshed have entirely disappeared, without doubt largely due to the exuberant energies of youth expending themselves

on the river and in the cricket and football fields. That there is the same inherent spirit as of yore in our Oxford students today was amply shown upon the call for Volunteers for South Africa, when Oxford students responded by sending a large contingent, some of whom have called for special commendation.

SHELDONIAN THEATRE

This fine edifice, one of the principal ornaments of Oxford, is situated in Broad Street, adjoining the Divinity School and the Clarendon Building. It was opened in 1669, having been built from the designs of Sir Christopher Wren, at a cost of, £15,000, the whole expense being defrayed by Archbishop Sheldon, who was at the time Chancellor of the University. He also bequeathed the sum of £2,000 for its support and repair. The ground plan is taken from that of the Theatre of Marcellus at Rome, and by its excellent arrangement is made to conveniently accommodate over 3,000 persons. The southern front is disposed in two storeys of the Corinthian style, and over the entrance are the Arms of Archbishop Sheldon, and in niches at the extremities are statues of the Archbishop and the Duke of Ormonde. The remainder of the building has a rounded front to Broad Street. The roof, 80ft by 70ft in diameter, rests upon the side walls without cross beams; it having been the first large building in Oxford so constructed, attracted at the time a great deal of attention. In 1802, it being feared the roof would fall, a new one was substituted; and it was again repaired in 1826. The ceiling has the appearance of painted canvas strained over gilt cordage, in imitation of the ancient theatres; it was painted by Streater Serjeant, painter to Charles II, in 1668, representing the 'Triumph of Religion, Art and Science over the Foes.' The canvas was cleaned and restored in 1762 at a cost of £1,000, and during the years 1900–01 a new outer roof has been substituted, and another restoration of the canvas painting took place at further cost of £2,000.

There are portraits of the founder, of James, Duke of Ormonde, Sir Christopher Wren, and Lord Crewe Bishop of

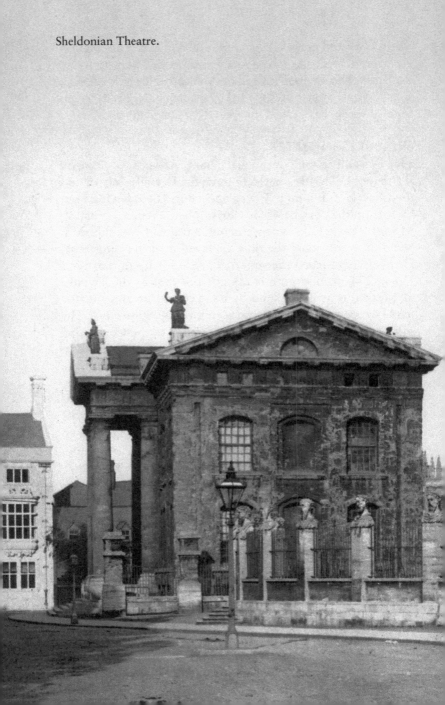

Sheldonian Theatre.

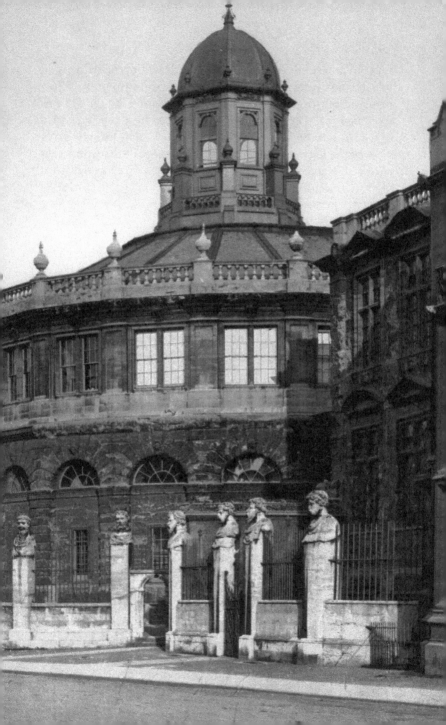

Lincoln and founder of the Creweian Oration, the delivery of which constitutes the 'Encaenia' (Commemoration). In 1876 a new and fine organ the Willis was substituted for the old one fixed in 1768. The building is surmounted by a cupola, added in 1838, having eight windows, from which an extensive view of the City can be obtained. The whole of the frontage is enclosed by a dwarf wall and iron railings secured to tall stone piers, terminating in seventeen huge grotesque heads, intended to represent various sages of antiquity.

THE UNIVERSITY MUSEUM

This large and handsome block of buildings, which was completed in 1860, is built in a semi-Gothic character, at a cost of about £90,000; to which has just been added a new wing, presented by the Draper Company, at a cost of over £20,000, to be used as the library. The grant from the University Chest each year is, £2,200, and its endowments nearly £1,000. The main entrance is by a finely carved doorway opposite Keble College, into a main court of 120 feet square, with a glass roof, supported entirely by ironwork in columns and arches, the heads of every column being enriched with foliage of wrought iron of different designs. The materials of the piers are of different geological formations, and 125 shafts are all of different rocks and marbles of the British Islands. The whole court is surrounded by an arcade on the ground floor, and a gallery above, from which access is obtained to the various and many departments. The theatre, or lecture room, on the first floor, will seat 500 persons. The Pitt-Rivers collection, one of the most attractive features to the non-scientific visitor, has a large room on the farther side of the main court especially devoted to it. The library, almost entirely consisting of works on physical science, contains about 50,000 vols. The building has a frontage to the Parks Road of nearly 400 feet, and is a very fine modern addition to the many beautiful architectural buildings of the University.

INDIAN INSTITUTE

This building, situated at the corner of Holywell Street and Broad Street, owes its foundation to the exertions of Sir Monier Williams, Boden Professor of Sanskrit, 'for the work of fostering and facilitating Indian studies in the University; and for the work of qualifying young Englishmen for Indian careers, and qualifying young Indians, who come to us for training and instruction, to serve their own country in the most effective manner.' The building, which was opened in 1884, is built somewhat in the Elizabethan style, with an octagonal tower, with decorations and cupolas. In the basement there are two lecture rooms and on the ground floor a reading room and a lecture room; with, on the first floor, an Indian Museum; more lecture rooms, and a fire-proof library, having fine oriel windows. The memorial stone was laid 'Albert Edward, son of the Empress of India, on May 2nd, 1883,' as the brass tablet in the entrance lobby has inscribed; and the building from designs of Basil Champneys, of London, was completed in 1896.

THE TAYLOR INSTITUTION

This is the eastern portion of a grand pile of buildings of Ionic style facing St Giles; the remaining port being in Beaumont Street and consisting of the Ashmolean Museum and University Galleries. The front of the Taylor Institution has four Ionic pillars; crowned with statues, personating France, Germany, Spain and Italy. It was founded from a bequest Sir Robert Taylor, who died in 1792, 'for the erection of a building for teaching and improving the European languages'; but its building was not completed until 1848. The interior consists of a spacious library, 40 feet by 40 feet; six lecture and class rooms, an superintendent's residence. The leading periodicals of France, Germany, Spain and Italy may always found in the Library.

ASHMOLEAN MUSEUM AND PICTURE GALLERIES

These buildings have an imposing frontage to Beaumont Street, being a reproduction of the temple Apollo Epicurus,

built 430 B.C., and consists of a central block with two
wings, the frontage being relieved by six columns supporting
a pediment crowned with a figure of Apollo; its length
being 240 feet by 100 feet deep, forming three sides of a
quadrangle. It was built with the Taylor Institution from
1841–49, at a cost of over £49,000. The Museum and
Galleries comprise a sculpture gallery on the ground floor,
and a fireproof gallery and picture gallery on the first floor.
A new building was added in 1894 at a cost of £15,000, for
the removal of the contents of the old Ashmolean Museum in
Broad Street to this site. It now includes the collection known
as 'Tradescant's Ark,' formerly at Lambeth, collected by John
Tradescant early in the seventeenth century; together with Dr
Fortnum's collection of bronzes, majolicas, and other artistic
relics; also the chief excavations of Professor Petrie in Egypt,
a fine collection of Greek vases, the Arundel and Pomfret
marbles, and the celebrated jewel, known as 'Alfred's Jewel.'

NEW EXAMINATION SCHOOLS

These buildings, erected from 1877–82, at a cost, inclusive
of site, of £100,000, are near the eastern end of High Street.
They were built from the designs of Mr Jackson, after the
Italian Gothic style; and from the opportunity which was here
given of displaying a double frontage, both to High Street
and King Street, gave scope to originality of design, which the
architect has most effectively shewn. The side to King Street
is apparently intended at some future period to take the place
of the High Street entrance and to be the principal front; its
plan being three sides of a square with the two wings thrown
forward. The present principal entrance is from High Street,
having a finely carved porchway with pillars on each side, and
being adorned in relief with appropriate scenes of University
student life – the one being the Viva Voce Examination and the
other the Conferment of Degrees. The frontage is relieved by
very fine mullioned windows and ornamental parapets to each
wing, crowned with delicate but effective louvre. The interior
abounds with marble and alabaster worked into the structure

in panels and balustrading to the staircase, with the rooms wainscotted with panelled oak, and the ceilings designed in panels of stucco in rich design. There are three Writing Schools of 114 feet, 110 feet and 90 feet in length and twelve viva voce rooms whilst the entrance hall or waiting room is 79 feet by 26 feet. The whole building is fitted with 19 electric clocks, and every room has electric communication with the official at the entrance hall. At the eastern corner of these buildings is a block devoted to the Delegate of the Non-Collegiate Students. This was erected 1887 and is built entirely in character with the other portion of the building; its front being relieved with three Gothic windows and gables to the High Street whilst near the corner of the building in King Street there is a very fine circular oriel window, crowned with a cupola.

THE RADCLIEFE OBSERVATORY

This was completed in 1775 from funds bequeathed by Dr Radcliffe at a cost of nearly £30,000, on land given by the Third Duke of Marlborough, nearly nine acres in extent. The buildings consist of a semi-circular block of two stories, with wings each 69 feet long. It has an octagonal tower, with a conical roof, on which are figures of Hercules and Atlas supporting a large globe. The tower was designed by Wyatt from the Temple of the Winds at Athens. Besides the rooms containing the best modern astronomical instruments there is a library, lecture room, and dwelling-house for the Observer.

THE BOTANIC GARDENS

These grounds, formerly called the Physic Gardens, are on the site of the ancient Jews' Burial Ground of the twelfth century. The Gardens were founded at a cost of £5,000 by the Earl of Danby, in 1632; the ground consisting of five acres on the banks of the Cherwell being raised to protect it from floods, and the whole of the site except the river front being enclosed with a high wall and an Italian gateway, from the design of Inigo Jones; the entrance is adorned with statues of Charles I and II. Several valuable bequests have since been made both

of botanical collections and of books, which are contained in buildings near the gateway. In 1894, a large new palm house, 40 feet by 30 feet, and other glass houses were added. The grounds are kindly thrown open to the public.

Amongst many other University Buildings deserving of our attention if space permitted, should be mentioned the University Printing Office in Walton Street, completed in 1830, built as three sides of a quadrant and having a frontage of 412 feet; the Clarence Building in Broad Street, erected in 1713, in the Classical style, designed by Hawksmoor, a pupil of Wren the Oxford Union Society's Rooms, with access from both Cornmarket and New Inn Hall Streets; and University Boathouse re-erected in 1881 on the banks of the Isis, a picturesque building in character with the beautifully decorated College barges serving Club-houses with reading and dressing rooms on opposite side of the river.

PARISH AND ECCLESIASTICAL CHURCHES

Oxford of today has between twenty and thirty parish and ecclesiastical churches. Four parish churches are mentioned, connected with taxation, in the Domesday Survey of 1086, viz.: St Mary the Virgin, St Michael, St Ebbe, and St Peter. It is known from other sources that St Martin, St Frideswide, St George-in-the-Castle, and St Mary Magdalen were also in existence, and it is therefore assumed the at least ten churches existed either within or just outside the ramparts of Oxford at that early date. Falkner in his History of Oxfordshire, says 'that by reign of Henry I (1100–35) there were certainly sixteen, and probably at least twenty, churches in the City.'

ALL SAINTS CHURCH

Situated in High Street, this was given by Henry I in 1122 to the canons of St Frideswide. Its vicarage was created in 1190, and it having been presented by Edward II in 1327 to the Bishop of Lincoln, was given to Lincoln College by Bishop Fleming, its founder, about 1427. The spire of the church having fallen through the building in 1699, the existing edifice was built in

1708, from the designs of Dean Aldrich, of Christ Church, its mixture of Corinthian and Italian style making it a striking feature of Oxford architecture. It is built in the Corinthian style, with a balustrade encircling the building, and has a finely ornamented tower with a graceful spire, altogether 153 feet in height. The interior is handsome and lofty, being remarkable for the extent of its span, 42 feet, without the aid of a pillar. Its interior was restored in 1866, its organ enlarged in 1896, and the tower and south front restored under the superintendence of Mr H. W. Moore during 1899/90. Since the removal of St Martin's Church from Carfax, in 1895, All Saints' has become the City Church, and is attended officially by the Mayor and Corporation every Sunday morning. The living is a vicarage in the gift of Lincoln College, and is held by the Rev. A. J. Carlyle, M.A., late Fellow of University College.

ST MARTINS

The body of the church was removed in 1896, for the purpose of widening Carfax, and other improvements, leaving the tower as a permanant memorial. The church is said to have been founded in 920 by Edward the Elder, although in the Chronicles of Abingdon Abbey is a story of its building, making Cnut its founder in the year 1034. Falkner in his record states that it was the first parish church in Oxford. The tower has been substantially restored without alteration of structure, and is practically the same tower with the addition of buttresses and turret a north-east angle carrying a flagstaff. By order of Edward III the tower was reduced in height in 1341 in order that the townsmen might not annoy the scholar with stones and arrows thrown from its summit. Th tower has an illuminated clock, which was presented by Mr G. R. Higgins, of Burcote; beneath which are placed a pair of old figures known as the 'quarter boys,' which have been preserved for many years in the City Library, and are now fixed to resume their old work of striking with hammers at every quarter hour. The tower preserves its peal of six bells, dating from 1678.

ST ALDATES CHURCH

This church takes its name from St Eldad, or Aldate, who lived about the year 430, and is said to have been founded or restored about 1004. It is a stone structure of great antiquity, having five arehes on the north side exhibiting traces of Early Normal work. Its immediate vicinity to St Frideswide and it being vested in Abingdon Abbey tend to prove its antiquity; whilst the fact that the upper part of the south aisle was in use as the Library of Broadgate Hall which had earlier also been part property of the Abbey confirms this supposition. Some of the stone seats or arched stalls in the chancel were discovered in the early part of the nineteenth century behind the panel-work. The present building is composed of various styles in excellent state of preservation, with a vaulted crypt under the south aisle. This aisle was built by Sir John Docklington, a Mayor of Oxford, in 1336, and the north aisle followed in 1455. In 1862 extensive repairs with enlargement took place, and the tower and spire were rebuilt in 1873 at a cost of £6,000; whilst the roofs of the nave and south aisle have since been renewed.

ST MATTHEW GRANDPONT

This church is a tithing of St Aldate's Parish, being separated from it by the Isis. It was formerly in the county of Berks, but by the Local Government Act, 1888, it was included in the extended Borough of Oxford. The church was built in the Perpendicular style in 1890/91 at a cost of about £8,000, the site being given by Brasenose College.

ST EBBES CHURCH

The present building was completed in 1816 in the Early Decorated style, the tower and a portion of the south wall being the remnants of the old church. The fine Norman doorway in the south aisle was carefully reconstructed during this rebuilding. The date of the original foundation is unknown, but the church is named after St- Ebbg, daughter of AEthelfred, King of Northumbria; who died in 605. The church was restored in 1865, and consists of chancel, nave, south aisle and tower.

In 1845 the District Church of Holy Trinity was added. It is built in Blackfriars Road, in the Early English style, all of stone; and consists of nave a two aisles. Erected at a cost of £3,400, which was raised by subscription.

ST PETER IN THE EAST

According to Wood this 'was the first church stone that appeared in these parts,' some historians claiming the ninth century for its foundation. It has an excellent Norman doorway, and a very fine cry beneath the chancel, having eight pillars and a vaulted roof – the crypt is said to be scarcely inferior in interc to that of Canterbury Cathedral. The church consists of chancel, with lady chapel, nave, north aisle, south porch and a western tower, remarkable for its construction, the walls sloping inwards from the base its summit.

ST MICHAELS CHURCH

The tower of this church is one of the most interesting of the many buildings of Oxford; its peculiar proportions, the long and short work of Saxon character shewn in the north angle of the tower, and the proof of its having been a fighting tower in not having a staircase, amply proves its antiquity. the church, which is a building of mixed styles of architecture, has incorporated the City Wall on its north side and has front entrance from Ship Street. It underwent a complete restoration in 1854, and consists of chancel nave, north chapel and south aisle, with tower containing six bells.

Space will not permit more than a passing notice of the many other churches of Oxford, included amongst which are St Thomas-the-Martyr, founded in 1141 by the Canons of Osney Abbey; St Mary Magdalen, granted to Robert D'Oyley by William the Conqueror, and transferred in 1129 to Osney Abbey by D'Oyley's son; Holwell, dated about 1160, last restoration 1845; St Giles', supposed date 1120, an interesting example of several stages of architecture; St Peter-le-Bailey (new church 1872), the old building, tradition states, was founded 748 by St Frideswide; Henry I confirmed

the holding of this church by the Nunnery in 1122. Amongst
the churches built in the last century are those of St Clement's,
St Paul's, St Philip and St James', St Barnabas', St John the
Evangelist, St Margaret's, and the Roman Catholic Church of
St Aloysius. There are also a large number of Nonconformist
places of worship, some of which are very fine buildings.

SOMERVILLE COLLEGE ST GILES

As an evidence of the appreciation of the facilities Oxford
possesses from an educational point of view, no stronger
case can be given than is offorded by 'Somerville's Ladies'
College.' This institution, which is undenominational, was
founded as recently as October, 1879; and in the short
space of 21 years has not only overcome all the difficulties
of establishment, but has now nearly 100 students. The
College was incorporated in 1881, for promoting the
higher education of women, and is intended for those
from a distance desiring to study in Oxford. In 1882 a
new wing was erected, and in 1887 it was again necessary
to enlarge by erecting new buildings opening to another
street (Walton Street), including dining hall; library and
gymnasium; and in 1893, further additions were made,
including lecture rooms and accommodation for 19 more
students. No student is admitted under the age of 17.
The terms generally correspond with those of University
residence, and students work principally for the Honours
Examination of University. The students have boats on the
river and a hockey field, while lawn tennis is played on
College grounds. It is endowed with two Scholarships of
£50 a year and one of £25.

LADY MARGARET HALL

Founded in 1879, in Norham Gardens, for the higher
education of women on Church of England principles. The
students number about 50 who; under the direction of a lady
principal assisted University lecturers. In 1896, a second hall
was built containing a dining hall and common room, with

accommodation for 25 students; other additions include a chapel, library, and gymnasium, and both summer and winter tennis courts and boat house.

ST HUGHS HALL

Also situates in Norham Gardens, this was founded in 1886 for women students preparing for University Examinations, who must be members of the Church of England. Students, who must be 17, are required to pass an examination before admission. The Halt has accommodation for 24 students, and has a dining room, chapel, library and common sitting rooms. The garden, adjoining the University Parks, has grass and gravel tennis courts, and the students, who have passed a swimming test, are provided with boats on the Cherwell.

ST HILDAS HALL

Situated in Cowley Place, this was opened in 1893, for the reception of women students from the Ladies' College, Cheltenham. It is conducted on the principles of the Church of England, but receives members of other religious denominations also. It has accommodation for 28 students.

HIGH SCHOOL FOR GIRLS

This was built in 1879, in Banbury Road, at a cost of £8,000. It is from the designs of Mr T. G. Jackson, and is in moulded brickwork in Queen Anne style; there is accommodation for 300 day pupils, and there are several connected boarding-houses. The course of instruction is of an extended character, and a special teacher is attached to the staff for physical training and a daily drill. The school is subject to an annual inspection and examination by the Oxford and Cambridge School Examination Board.

ACCOMMODATION

There is no lack of Hotel and Boarding House accommodation, conspicuous among the latter may be mentioned 'The Isis,' which is pleasantly situated, facing Christ Church

Recreation Grounds five minutes from Magdalen College and Examination Schools, and 'Wolsey House,' a newly-established boarding house in a building of ancient and historic interest. It is centrally situated, opposite Chris Church College and close to the river.

THE RIVER

One of the greatest attractions to Oxford is undoubtedly the river, known locally as the 'Isis'; and during recent years its attractiveness has been considerably increased by the opening up by Messrs. Salter Brothers, of an excellent daily steamer service between Oxford and Kingston, which by special arrangements with the Great Western Railway Company, also combines a circular trip of half railway and half steamer. Upon viewing the river from Folly Bridge, which was built in 1826, at a cost of £18,000, one is struck with the beautiful appearance of the long rows of the College barges; nearly every College, for racing and training purposes, having a barge stationed on the Oxfordshire side, beautifully fitted up for use as a club-room, with dressing and reading rooms. Many thousands of visitors and citizens line the banks and crowd the boats during 'the Eights' Week,' which has now come to be recognised as the Visitors' Week, and the principal event of the Summer Term at Oxford, it being such a scene of animation and excitement as once witnessed would be ever after remembered. These contests are rowed in two divisions of about twelve boats each, starting at equal distances behind each other. The boats are eight-oared, with a coxswain, who endeavours to displace the boat preceding him by 'bumping,' or striking the boat, each crew being distinguished by the coloured jackets and crests of their College, whilst the excited shouts and cheers of their partisans on the banks are heard miles away. Besides the London steamers giving the daily service, the ordinary local steamer traffic has grown very rapidly during recent years; every evening during the summer season there is a service of steamers from Folly Bridge to Iffley at frequent intervals at a fare of twopence each way; whilst also, for privately organised

parties, steamers may be chartered for trips to Nuneham, Abingdon, and other places farther down the river at a very moderate charge. At the distance of 1¾ miles from Folly Bridge is Iffley Lock, one of the three locks that were provided for by Act of Parliament in 1624 'for opening of river from Burcote by Abingdon, for the benefit of the University and City of Oxford' – the other locks being Sandford and 'Culham in the swift ditch'; as a result of the water being thus kept up the first barge was brought up to Oxford on August 31st, 1635. Adjoining the lock is the ancient Mill of Iffley, which can be traced back nearly to Norman days. Just below the lock is a charming view of the old Norman tower of the church, which for 750 years has crowned the garden of the vicarage. About a mile further down the river is approached a noted riverside hostelry, 'Kennington Island,' at which many kodaks have been snapped, and which has produced many an interesting reminiscence of a river trip. Immediately upon passing Sandford Lock, 3½ miles from Oxford, the river begins to open out, and presents a series of charming and interesting scenes, both in an abundance of low-lying grass lands, and fine hills crowned with splendid timber. Continuing through this beautiful scenery, six miles from Oxford we approach Nuneham Courtenay

NUNEHAM COURTENAY

The estate is a very ancient one, and acquired name from Robert de Courtenay, who, in 1214 married into the family of William de Redvei Earl of Devon, who had previously been lords of the manor. In 1710 the estate passed into the hands Simon, Lord Chancellor of England, the first Baron and Viscount Harcourt, by purchase, at a cost of £17,000. In 1772 the village was removed to present site on the London Road, from its old position near the house, which is a plain stone building consisting of a central block with wings, connected corridors. The gardens are very fine, and under certain restrictions, with the park, are thrown open the public on Tuesdays and Thursdays from the beginning of May till September, and are a favourite trip by steamer or

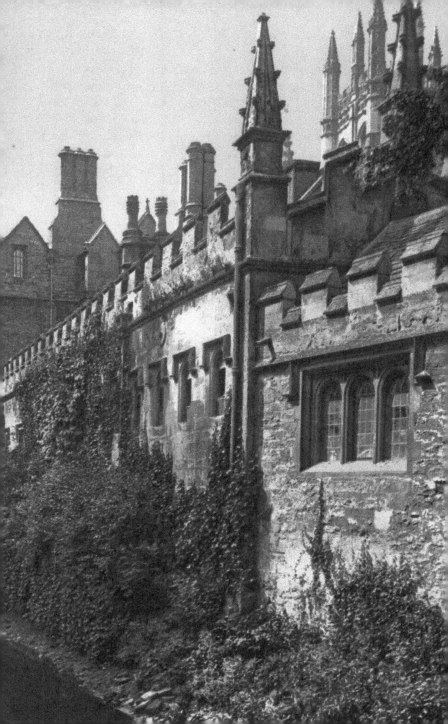

houseboat during the season; the usual charge being one shilling for the double journey. In the Park, rising steeply from the river bank some 250 feet, is carefully preserved an old Oxford relic, which was erected on Carfax in 1616, as a conduit for the supply of water for the University and City. This enterprise was carried out at the sole expense of Otho Nicholson, of Christ Church, who brought the water in pipes from the hillside above North Ilincksey, at a cost of £2,500. After standing over 160 years in the very centre of the City, to the great detriment of the carriage-way, it was removed in 1787, being presented to the Earl of Harcourt, who re-erected it upon its present site. From the river at this spot is obtained one of the very best views on the Thames, having a rustic oak bridge in the foreground uniting the woods which come to the water's edge with an island adorned with tall willows; the background being relieved with old cottages with thatched roofs and greensward in front of this being the landing-place provided by the courtesy of the Harcourt family for the convenience of visitors.

IFFLEY CHURCH

Iffley, as a village or hamlet, is said to have held an important position for a long time before the Conquest, owing to its having been a recognised fordway between what are now Oxfordshire and Berkshire. The first recognised mention of Iffley is in the Chronicles of the Abbey of Abingdon, described as 'Gifteleia,' referring to the date 941–46. In *Diocesan Histories* the date of the Church is given as about 1160, and in Domesday (written in 1086) no mention is made of the church, although it is stated 'Earl Alberic held of the King, Giveteleia, in which were four hides of land (a hide being 120 acres), worth one hundred shillings.' Dugdale says that the grant of Iffley Church and Rectory to Kenilworth was made in the time of Henry II (1154–89), as about the year 1180 a dispute arose between the Canons of Oseney and Robert de Germano as to the patronage of Iffley Church. It is at a distance of two miles from the City, and is easily accessible by Tramway Company's buses from Broad Street.

The church exhibits some of the purest and most perfect specimens of Norman work still existing. It is supposed to have been erected either by Robert de Cheney, Bishop of Lincoln, about 1140, or by Juliano de Remigio a little later, who gave it to the Priory between 1175 and 1195. It consists of chancel and nave, with massive embattled tower in the centre. The west front is of three stages, the lowest having a deeply recessed doorway with richly carved chevron and beak mouldings, on either side of which is a blank round-headed arch; the next stage contains a most handsome circular window with chevron mouldings, restored about fifty years since by Dr Warburton, the Vicar, from designs prepared in accordance with traces of the original window remaining in the wall, this splendid window having a circumference of about 30 feet. Above this are three windows in line, with shafts and capitals and highly enriched mouldings of similar character, and in the apex of the gable another single-light window. The north and south doorways are also Norman, with ornamented piers and capitals; only the two west windows on either side of the nave remaining in their original style, but the mouldings of the others remain in the interior; the five windows on each side displaying in the construction of arches five different characters of architecture. The tower arches spring from piers with cushioned capitals and shafts of black marble, whilst the two arches are recessed and elaborately carved with flowers and zig-zag work. Extensive repairs were made in 1823 and 1844; in the latter year the western gable was reconstructed, and the nave roof restored to its original height. The chancel, which was restored in 1858, is vaulted with stone and groined, its splendid ceiling being completely in character with the older work. It consists of two bays, the western one being Norman, and the second Early English, supposed to have been added to the original church by the Prior of Kenilworth, Robert of Efteley, about 1270. The later windows and the chancel are of the thirteenth century, and in the Norman portion the mouldings of the ancient windows remain. In the tower and nave four Perpendicular windows have been inserted with the

Norman mouldings, dating from the latter half of the fifteenth century. The tower has also, in the belfry storey, two Norman windows on each side, and a turret at the north-west corner; in the centre of the north row of battlements is the figure of an ox. The font, which is a very early and curious example, is of black marble, about 3ft 6in square, supported on a circular stone pedestal, with four smaller ones at the angles. An old altar-tomb existed at the time of the restoration of church, on the north side of the chancel; this be destroyed, the upper slab, unfortunately without brasses, was removed to the west wall of the chur where it still remains, to the memory of Arthur Pitts B.C.L., of Brasenose College, Archdeacon; Registrar of the Diocese, who died 1579. In churchyard is a cross, the base and shaft of which ancient; it being generally understood to express the it was evidence of the church being consecrated; the churchyard entitled to the right of sanctuary, wh did not extend beyond a distance of thirty yards from the church door. There is also adjoining a venera yew tree, the trunk of which is hollow from age and said to be as old as the church.

IFFLEY MILL

The picturesque appearance of Iffley Mill has been for many years a great attraction to artists and photographers. There has been a mill here almost from time immemorial. The *Muniments Magdalen College* state that 'William, the son Manfred the Miller, gave sixpence of annual rent to the Hospital of St John the Baptist,' after the death Juliana de Remigio, who died in 1220. In the time of Edward I it was noticed 'with free water fishing from the village of Iffley to the mill called Boymille, but there is an annual rent of 44 shillings the lord of the manor.' Since the year 1466 it known to have belonged to Lincoln College, together with land adjoining and the right to the fishery; as in evidence produced by the College before a Select Commission on the Thames Navigation Bill in 1856, a receipt was produced of the year 1466 for a reserved rent of three shillings to the Priories of Littlemore. In 1622 Sir Thomas Stoner and William Wickham of Abingdon 'gave

£400 to Philip Pitts, of Iffley, for his interest in a lease of sixty-five years granted by Lincoln College in the time of Queen Elizabeth to his father Arthur Pitts.'

BLENHEIM PALACE

This magnificent building which was commenced in 1705, and was about 20 years in erection, is not only in itself, as the master-piece of Sir John Vanbrugh, a very great attraction, but the interest in the estate of Woodstock is very greatly increased by the historical associations of the Royal Houses of England with the Borough, through several previous centuries. During the Saxon times we find King Alfred made his residence at Woodstock, whilst in Ethelred's reign he summoned Parliament to meet here. Henry I rebuilt his palace here, enclosing the park and stocking it with deer; Henry II also used it as his favourite residence, his mistress, Fair Rosamond, having a concealed bower in the woods, and dying here in 1177 was buried at Godstow Nunnery, two miles from Oxford, the ruins of which are still in existence. Henry VIII made large additions to the palace, and Elizabeth was later confined as a

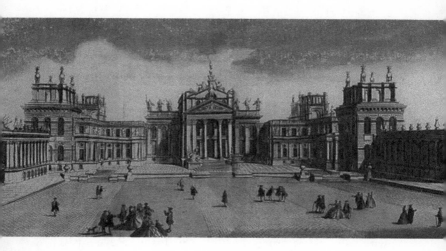

Blenheim Palace.

prisoner in the gatehouse by Mary whilst she was Queen. In the reign of Queen Anne, the Manor of Woodstock, together with Wootton, was granted to John Churchill, the great Duke of Marlborough and his heirs for ever. The site consists of about 22,000 acres; and the grant having been confirmed by Act of Parliament, the sum of £240,000 was granted for the erection of the palace which was not completed at the death of the Duke in 1722. The building, which is entirely of stone, is said to have cost over £300,000, and consists of a long block with square towers at each end, and wings connected by colonnades, forming three sides of a larg court entered by an archway. The whole area of the buildings occupies three acres, and has a north frontage to the park and a south frontage to the lawns – both frontages being 348 feet in length. It is quite impossible to attempt justice to such a building a Blenheim Palace, as the notice of the several departments must necessarily be very brief in a book of this character. A visit to Blenheim may perhaps best be summarised in the words of a German visitor, who said: 'If nothing were to be seen in England but Blenheim, there would be no reason to repent the journey to this country.'

Upon entering the outer court one is struck with th massiveness of the entrance gates, which are 22 feet in height, and weigh 17 tons. The centre is ornamented with a gilded trophy of arms, standards and drums the upper portion showing the family crests. The first court is devoted to the usual offices of a larg estate, and passing through a second archway with handsome clock tower we approach the north front, consisting of a magnificent Corinthian portico, by a handsome flight of steps flanked with pedestals, on which rest two saluting pieces from the field of Blenheim. The hall, which is 75 feet by 40 feet, has a handsome ceiling, 67 feet from the floor, adorned with a large allegorical fresco by Sir James Thornhill, commemorating the Victory of Blenheim in 1704. The small drawing room is 24 feet square, its walls covered with valuable paintings, including Sir Joshua Reynolds' 1778 picture of George, Third Duke of Marlborough, and his

family, which is valued at £40,000. Proceeding from this room we pass through the Grand Cabinet, 27 feet by 28 feet, in which is the celebrated letter written by the Duke on the field of battle, and known as the 'Blenheim Despatch'; next is the billiard room, 33 feet by 23 feet, followed by the dining room, the walls of both of which are hung with tapestries copied from pictures by Le Brun in the Louvre of Paris. The Saloon, a magnificent apartment, 44ft by 35ft, follows, the whole of the decorations and ceiling being painted by Laguerre; the latter being an allegorical representation of the career of the First Duke. Following upon the Saloon, we enter in succession the three handsome State Rooms, the walls of which are hung with those splendid tapestries', made in Brussels, which have so long been known as a special feature of Blenheim Palace. In the first room they represent the sieges of Donawert in 1704, and Lisle in 1708; the second room, in continuation of the series, shows the march to Bonchain and its siege in 1711; while the third represents the sieges of Bonchain and Oudenarde. The Long Library is the largest room in the Palace, being 183 feet by 24 feet; it has a magnificent ceiling, and some wood-carving of Grinling Gibbons on the bookcases. The organ, built by Willis and Son, is a special feature of this room, it being the finest private organ in the world, requiring six hydraulic engines for blowing it. The most interesting feature of the handsome chapel is the superb marble monument to the Duke and his two sons, erected by the Duchess in 1733, having colossal figures of the Duke, Duchess and their two sons, attended by Fame and History. The Lake occupies a space of 130 acres, having in the immediate front of the house a grand bridge, with central arch of 101 feet span, the bridge having chambers within. At the north end of the bridge marked by a clump of beech trees, is the site of the ancient Palace of Woodstock, in which Queen Elizabeth was prisoner. The Park contains over 2,400 acres and has a circuit of nine miles. The Palace and Gardens are open to the public on Tuesdays and Friday from 12 to 3 during the months of May to September at a charge of 1s, the proceeds being given to charitable institutions.

R. S. Rowell,

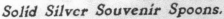

Solid Silver Souvenir Spoons.

University, 5/- each ; City, 6/- each.

Enamelled in Colours—
University, 10/- each ; City, 9/- each.

The "Isis" ____

Boarding Establishment,

❧❧ Iffley Road, Oxford.

ENGLISH and AMERICAN HOME and
INTERNATIONAL PENSION.

Established
1894.

**Smoking and Bath Rooms.
Cycle House.** ✠ ✠ ✠

From £1 5s. to £2 10s.
Weekly.

Day Terms from 5s. to
7s. 6d.

Proprietress—

MRS. JEFFERY.

W. BAKER &

One of Our Immense Showrooms.

).,

OF OXFORD.

The Oxford Ewer.

&° &°

ELAIN.

*Models in
Miniature
of
Ancient
 Jugs,
Bronze -
 Pots,
Urns, etc.*

From the original in the
Ashmolean Museum.
Found at Exeter College

In two sizes.
*Heights, 3in. and 5in. Prices, **1/3** and **2/3**.*
Postage extra.

ATCH,

STREET,

William H. Alden, «««

The Oxford Photographic and Fine Art Galleries. ✄ ✄ ✄

Photograph_
late Que_
Royal F_

Established
Forty ye_

Gentlemen's
Photogra_

All College Gro_
Club Groups

Portraits of Ce_
and Actre_

Skilled Operat_
to any part
Country_

THE
FINEST COLL_
OF VIEWS OF
COLLEGES, CIT_
NEIGHBOURHO_
Both in
and Pla_

Wolsey House,

CENTRALLY
SITUATED.

ST. ALDATE'S.
OXFORD.

Select Boarding Establishment,

NEWLY-OPENED

Close to t*
River.

In House of Historical Interest.

Opposite Christ Church.

Apply, Proprietres

MR. EDMUND J. BROOKS,

F.A.I.

ESTABLISHED
1840.

Auctioneer, Valuer, &
House and Estate Agent,
Surveyor, & &
Insurance Agent, etc.

SALES of Real Property, Household Furniture, Timber, etc.
Periodical Sales of Freehold and Leasehold Properties
and Shares.

VALUATIONS of Real and Personal Property, Tenant-right,
Timber, Hotel, and Public-house Fixtures, and for Probate,
Estate Duty, and Mortgage Purposes.

INVENTORIES TAKEN AND DILAPIDATIONS ASSESSED.

Accounts audited and kept. Mortgages arranged.
Rents collected. Estates managed and Surveys made.

Insurances effected against Life, Fire,
Accident, and Burglary Risks.

Telephone No. 0329 Oxford.

Offices :—

14 & 15, Magdalen Street, Oxford.

ENGRAVINGS, DRAWINGS, AND PAINTINGS
CLEANED AND RESTORED.

FRAMES REPAIRED AND
GILT EQUAL TO NEW.

Experienced Workmen sent
to all parts of the ::
Kingdom.

Mayo's Store

(LATE STEANES).

Importers,

Bonders,

Dealers.

Front Vie

Wines. ❧ Spirits. ❧ Liqu

41 & 42, Cornmarket Street, OXFORD.

ESTABLISHED 1826.

Premises.